BOB DYLAN

IN THE 1970s

BY CHRIS WADE

Bob Dylan in the 1970s

by Chris Wade

Wisdom Twins Books, 2017

wisdomtwinsbooks.weebly.com

This edition released in 2017

Text Copyright of Chris Wade, 2017

All rights reserved. No part of this publication may be reproduced, stored in a retrieval system, or transmitted in any form or by any means, electronic, mechanical, photocopy, recording or otherwise, without prior written permission of the copyright owner. Nor can it be circulated in any form of binding or cover other than that in which it is published and without similar condition including this condition being imposed on a subsequent purchaser.

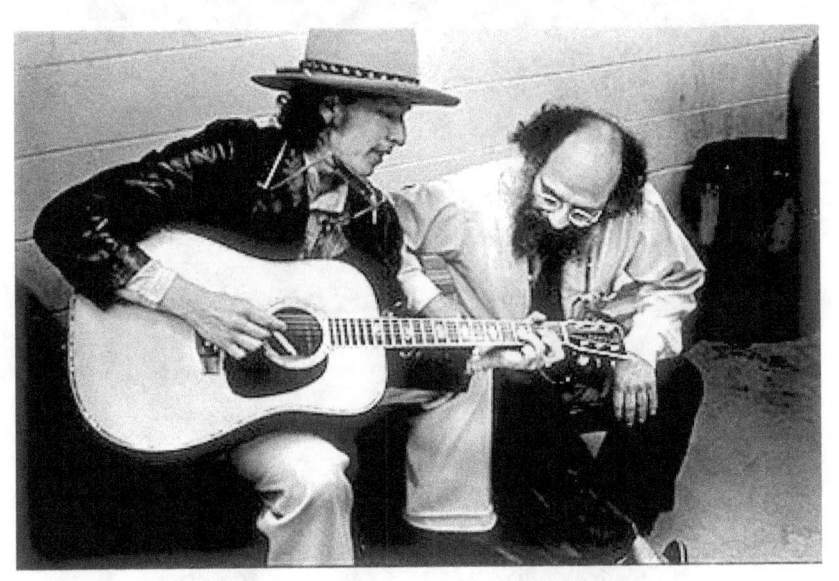

BOB DYLAN
IN THE 1970s

CONTENTS

6	Introduction: Changing Times
10	Self Portrait: Embracing the Bizarre
20	New Morning
28	Greatest Hits 2
34	AJ Weberman Vs. Bob Dylan
38	The Dylan Album
46	Pat Garrett and Billy the Kid
52	Planet Waves
60	Blood on the Tracks: The Ultimate Break Up Album
82	The Unearthing of the Basement Tapes
90	Desire: Inspired Brilliance with Jacques Levy
102	Dylan, The Band and Their Last Waltz
106	Renaldo and Clara: The Rock Icon and Grand Cinema
124	Street Legal
130	Bob Dylan: Live Artist in the 1970s
142	Slow Train Coming and the Dawn of Christianity
150	Postscript
153	1970s Discography
155	References and Acknowledgements
156	About Chris Wade

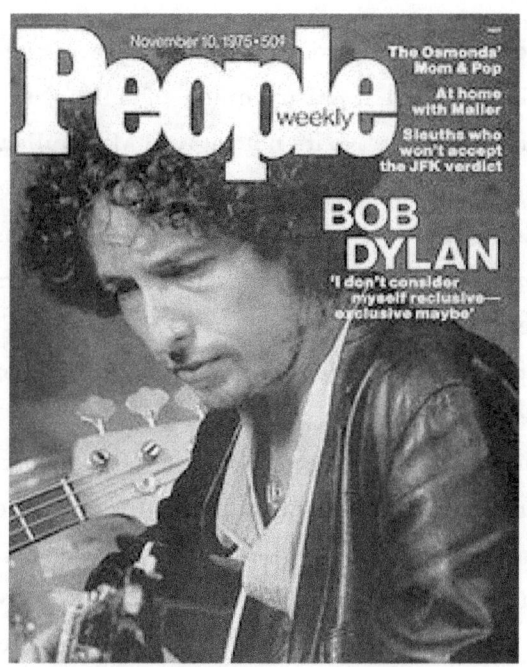

INTRODUCTION
CHANGING TIMES

Bob Dylan's London Art, Trump's Presidency and the Death of Leonard Cohen

As I write this, it's the day after the news has spread of the passing of folk poet hero Leonard Cohen, and the same strange week that Donald Trump has become President of the United States. Filmmaker, author and photographer Lawrence Schiller was recently speaking to me on the phone, and some of his words seemed to sum up the sheer nightmare quality of modern times. He was talking about Charles Manson, when he said, "I'm not sure where that evil

came from. No one could figure that out. Now we're trying to figure out Trump." I suggested it wasn't much of a leap, from Charles Manson to Donald Trump. "No it's not," agreed Mr Schiller.

In the surreal days we live in, I am briefly calmed by the news that nearly all of Bob Dylan's new artwork in his latest London exhibition has been snapped up by collectors. investors and admirers alike, and that he has been awarded the Nobel Prize. There is still some light after all. The prize means little to Bob, although he seems happy to accept it, just not in the flesh. But more interesting to Bob, rather than resting on past laurels. is his paint work. Dylan's art has always been fascinating and original, but he seems to have reached a new height these days. His work now stands on its own, not as a mere curiosity because it happened to be painted by the world's finest and most revered singer-songwriter, but for its sheer quality. He has a masterful style, capturing brilliantly whatever he turns his attention to. In a time where we are gazing back towards better or more simple times, Bob Dylan keeps moving forward.

I have to reiterate the fact that now more than ever, society is looking backwards and we as a collective species are suckers for nostalgia like never before. And it's little wonder. We live in a dark age of greed, cynicism and PR overload. The words and music of Leonard Cohen seem almost biblical now, music made by some wise prophet a life time ago. And now he's gone. But Bob Dylan remains active; he is still touring, releasing albums and being an enigma. Dylan is now enjoying his most successful phase in years. He's in his mid seventies, but is remarkably more relevant than ever.

But still, we find ourselves looking back. Though I love all Dylan eras, the time I find the most interesting are the 1970s, a very hectic

decade for Bob, no doubt about it. There he was, a man who had experienced ten years of being an icon and a voice for a generation, going into his thirties as a family man, rejecting his status. It was a turbulent era too, taking in a marriage break up, massive world tours, travelling revues and some classic albums. It's as fascinating time as any other phase in the winding story of Bob Dylan.

This book is a collection of articles and essays on Dylan's work in the 70s, studio albums, tours and moments I have stopped at and examined. I have broken up the pieces with my own artwork of Dylan, as well as pictures and albums covers. There are also sound bites from my interviews with those who worked with him in this era. Dylan of the 70s was an ever changing artist, and it was arguably this decade which shaped the man he became in later years. So let's investigate that remarkable time.

SELF PORTRAIT
Embracing the bizarre

"Well, it wouldn't have held up as a single album—then it really would've been bad, you know. I mean, if you're gonna put a lot of crap on it, you might as well load it up!" - Bob Dylan

It would be easy to start this article off with the usual talk of how much of a kicking Self Portrait received upon its release in 1970, but as Dylan admirers, we all know it wasn't appreciated upon release. Of course that's a massive understatement, for the album was widely mocked, rubbished and verbally shat on by every critic across the land. Where was the mercurial Dylan of the mid sixties? Had he lost it in the motorbike crash? Had his detours into commercial "hick" music on the likes of Nashville Skyline affected his brain? As one of

the biggest voices in the press asked when the album first hit the shelves, Mr Greil Marcus: "What is this shit?"

Admittedly, Self Portrait is a very curious set, basically a double album of covers, bits and bobs and half done ideas. But consider the literal idea of a "self portrait" as a painting, which can either be a perfect photo-like copy of its subject, or a rough-around-the-edges, splash of abstract features. Funnily enough, it's often the latter that seems more expressive and captures the true essence of the person sitting for the portrait. This is how I view Dylan's Self Portrait. It's a free form expressionist painting, what Pollock might have done with sound. But that's just one view of the record. My mind reaches ever more varied conclusions every time I hear it again.

Dylan's own views of the record have changed drastically over the years, ranging from pride to amusement to indifference. In the 1971 book on him by Anthony Scaduto, Dylan told the author, "There's a lot of good music on there. People just didn't listen at first." In 1974 however, he claimed the album was scraped together. His most revealing interview came in 1984, when he went a little further into the Self Portrait controversy to Rolling Stone.

"At the time, I was in Woodstock, and I was getting a great degree of notoriety for doing nothing. Then I had that motorcycle accident, which put me outta commission. Then, when I woke up and caught my senses, I realized I was just workin' for all these leeches. And I didn't wanna do that. Plus, I had a family, and I just wanted to see my kids. I'd also seen that I was representing all these things that I didn't know anything about. But people need a leader. People need a leader more than a leader needs people, really. I mean, anybody can step up and be a leader, if he's got the people there that want one. I

didn't want that, though. And I said, "Well, fuck it. I wish these people would just forget about me. I wanna do something they can't possibly like, they can't relate to. They'll see it, and they'll listen, and they'll say, 'Well, let's go on to the next person. He ain't sayin' it no more. He ain't givin' us what we want,' you know? They'll go on to somebody else." But the whole idea backfired Because the album went out there, and the people said, "This ain't what we want," and they got more resentful. And then I did this portrait for the cover. I mean, there was no title for that album. I knew somebody who had some paints and a square canvas, and I did the cover up in about five minutes. And I said, "Well, I'm gonna call this album Self Portrait." And to me, it was a joke!"

If Dylan thought it was a joke, his army of followers missed the gag. Dylan was approaching 30 at the time, and in the sixties/early seventies pop and rock world, 30 was practically ancient. Had their hero grown "old" and resided himself to middle of the road pap? Had he really become Dylan the crooner, and was this new Kermit the Frog voice the only way to express himself? People were genuinely shocked.

Some 46 years later though, you have to ask just what were they so shocked about? After all, Dylan was a baffling artist from the very beginning. He was the voice of the people, whether he liked to be or not, singing folk protest anthems that stuck up for the minorities and the ones without a voice of their own. He had angered his worshippers, this twenty four year old man, by going electric and bringing his songs into the rock arena. Dylan goes pop! The outrage! After his crash, he'd stunned them again with the sparse John Wesley Harding, released in 1967, a gorgeous but stinging record with

acoustic, bass, drums and ear splitting harmonica. Dylan was loved for his way of shaking up the apple cart and taking things in new directions. It seems odd today that his audience couldn't see past the lush strings, delicate croon and half baked ideas, and understand where Dylan was coming from. Hindsight is a wonderful thing.

If Dylan really did make the album to shatter his own myth - and why shouldn't we believe him? - you can understand why he might have wanted to do so. He was a man who felt like his blood was being sucked from his body, by both the label men and some of his more vampiric followers. But these followers were no longer on board for the music, the poetry and Dylan's wonderful world view, but for Dylan the man, and who he was, or more to the point was not, behind the songs. This was the aspect of celebrity which Dylan struggled with. And who can blame him? Fame these days is one thing, but imagine being Dylan the Prophet back in the late 1960s. A quiet man like Bob must have been in his own personal hell. Ironically though, and inevitably given Dylan's natural appeal and his audience's obsession for him, Self Portrait only made him more of an enigma. It backfired to say the least.

My own opinion on Self Portrait tends to change slightly from time to time. I always like it, no question, but I often wonder am I enjoying the album for what it is on a musical level, or because it's a statement by Bob Dylan. Am I one of those people who fall for his mystique, his eccentric aloofness? Am I of a mind to suggest that everything Bob does is genius, or some prophetic statement about himself and us all? I hope not, but I do often believe I am more won over by the approach and idea of Self Portrait, rather than the work itself. Like a piece of challenging act, you are often not dazzled by the

technique itself, but floored by the concept behind it. I view Self Portrait the same way, as a bold concept and statement about Dylan's status as a reluctant icon.

The outtakes of Self Portrait and its speedy follow up New Morning were made available on the 2013 release, The Bootleg Series Vol 10: Another Self Portrait, and on that double set was some genuine gold, much of it stronger than what made it on to the two records. Some of the material put out on that collection are among my personal favourite Dylan recordings. And I must stress, the released version of Self Portrait also has its fair share of gems too, in between the more baffling material. Perhaps a single album would have been a good idea after all.

Alberta #1 is a wonderful, understated piece with a cool Dylan vocal, laid back drums and a nice harmonica solo; perfectly passable Dylan fare; not extraordinary by any means, but a song that would have fit snugly on to any classic Bob record. It's hard to imagine anyone getting genuinely riled up by a song like this. However, I can see the ranting and raving Dylan converts and followers, who hung on his every word back in the late sixties, rearing back in horror at his genuinely beautiful cover of I Forgot More Than You'll Ever Know, his voice in full on Nashville Skyline mode. With sweet musical accompaniment, Bob makes the song his own. The slide guitars and plucking acoustics back up his smooth vocal quietly.

Days of 49 is solid Dylan too, a cover made his own with a charismatic vocal and sparse backing of bass and drums, plus a little brass on the chorus. It's a great moment on the album, in my view one of the finest tracks here. His take on Gordon Lightfoot's Early Mornin' Rain is a strange addition, but a decent retelling too, while In

Search of Little Sadie is a little messy, less effective than Little Sadie which follows on the second side. A traditional classic, also done nicely by a favourite band of mine called Trees, Dylan handles it with ease in his croony voice, with manic bongos, slapping acoustics and tidy bass on musical back up.

I even admit to liking Woogie Boogie, a jagged rock and roller with nice piano, brass and guitar interplay. It's often slagged off as inconsequential, but personally I love the groove the band get going. Brief songs like Belle Isle and Living the Blues are nice enough, though they don't shake the needle too much. The Isle of Wight 69 recording of Like A Rolling Stone is excellent however, a cool reimagining of the classic number with a more laid back vocal.

The most acclaimed song from Self Portrait is Copper Kettle, written by Albert Beddoe but made Dylan's own with an understated arrangement of acoustic, bass and female backing vocals, not to mention the subtle and effective strings at work. Joan Baez made it famous in the early 1960s, perhaps explaining Dylan's decision to cover it on his own Self Portrait. After all, Baez had been an important character in his early years, and no Self Portrait would be complete without an appearance by the queen of folk herself. The vocal is off key, but there is passion to his performance that lifts it up above the flaws in the recording.

I heard Dylan's cover of Blue Moon a lot when I was growing up (it was a curious favourite of my dad's when I was a kid), and I must say for me it's the definitive version, although that might be more to do with my familiarity with it rather than the recording's merit. In truth though, it has that kind of backing I love from the Self Portrait/New

Morning era; shuffling drums, heavy bass and clear acoustics. The violin solo is beautiful too.

Though his cover of Paul Simon's The Boxer is questionable, it's a nice enough version, with a curious double vocal mix that does distract the listener somewhat. On a side note to this odd choice of cover, Paul Simon often seems to have been riled up that he's considered "second place" to Bob Dylan, but then again so is everyone else, so he's in good company. However, over 40 years after Dylan paid homage to Simon on Self Portrait, he was still irritated by his inferiority to Dylan.

"I usually come in second to Dylan," Simon moaned recently, "and I don't like coming in second. In the beginning, when we were first signed to Columbia, I really admired Dylan's work. The Sound of Silence wouldn't have been written if it weren't for Dylan. But I left that feeling around The Graduate and Mrs Robinson. They weren't folky any more. One of my deficiencies is my voice sounds sincere. I've tried to sound ironic. I don't. I can't. Dylan, everything he sings has two meanings. He's telling you the truth and making fun of you at the same time. I sound sincere every time."

Simon was also sulking that Bob turned down his request for a duet. However, knowing Dylan's marvellously eccentric behaviour, Simon should not have been surprised. And Dylan's quietness and reluctance to speak out about things gives him an air of class, as well as some vaguely frustrating mystery, and he is above slagging matches in the press. Simon however, he's another matter.

"I consider him one of the preeminent songwriters of our time," Dylan told USA Today in 1999, just before touring with Paul. "Every song he does has got a vitality you don't find everywhere." His kind

words for Simon seem to explain his use of The Boxer on the apparently personal Self Portrait record. Then again, it could also just be a casual, last minute addition to fill some vinyl space. Or, perhaps, even a joke. Who knows?

For me, one of the additions that makes the sense most, and indeed sticks out from the set, is the Isle of Wight version of She Belongs to Me, a wonderful song when it first appeared on record and perhaps even stronger in the live setting of 1969. These moments, more frequent than most people choose to believe, are the reason it's worth sticking Self Portrait out to the end. And in the end is the charm of Alberta #2, a fitting finale to a most perplexing set.

I am not sure if Dylan was happy or put out by the album's negative response. If he aimed for a turn around of his reputation, he might have been pleased by the bile. But the truth is that he probably didn't even care. It's true that Bob often comes across as arrogant in his indifference (his recent low key reaction to the Nobel Prize seems to have annoyed folk who don't get the way Dylan is and always has been), but his shrugging attitude is actually refreshing. Singers, celebs and people in the spotlight are often so desperate to please us, to get good PR, to say the right things and keep their fans, that Dylan's refusal to be led or influenced by anyone or anything has made him a true artist for some 55 years. Self Portrait, in my view, is about so much more than its content. It's a statement, and a statement from Bob Dylan cannot really be ignored.

Griel Marcus, the very critic who pissed all over Self Portrait back in 1970 for Roling Stone, recently spoke of the record. "A few years ago, Mojo asked me to come back and listen to the record again and write about it again," he said. "I tried really hard to listen to it and

hear where I might have been wrong. The stuff that I liked before sounded even better. The stuff that I didn't like before, like the Everly Brothers Let It Be Me, was worse. I don't know why he released the version he did. Maybe it *was* meant to be a moat to keep people away."

Keeping people away or not, 46 years later and this is totally irrelevant. Like historic paintings from centuries past, we now judge them for their artistic and aesthetic content, not for the reasons they were created. When enough time passes for critical reactions and artist's defences to disappear out of importance, all that remains is the work. As actor and director Dennis Hopper says in the documentary The American Dreamer, "A man only leaves his work. I'll be dead one day." Viewing Self Portrait as a stand alone piece of work reveals a flawed, mischievous and confusing record, but one with enough going for it to make it work on its own merit. Yes we talk about Dylan's reasons for making it, but the real issue now is how it stands the test of time. Ignore it's Bob Dylan all together, and it really is, dare I say it, a pleasant album. Putting aside the harsh battering it took, and you would think Self Portrait was just a nice, laid back, easy listening, ditty filled record from fifty years ago - which, in a lot of ways, it is.

NEW MORNING

Critics and observers have often noted that the highly positive reaction garnered by Dylan's 1970 release New Morning was ever so slightly over the top. They also add that the album didn't actually deserve such monumental praise as "We've got our Dylan back!" They were maybe just relieved it wasn't Self Portrait part two. Personally I feel New Morning is a wonderful little album, both understated and monumental at the same time. The record's harshest critics wonder why it gained such a hysterical reaction, when there is supposedly so few earth shattering revelations on it. Were people just so happy that Dylan had left behind the easy listening oddness that ran through much of Self Portrait, that they would be happy with anything slightly more typical of mid sixties Dylan? Why else would they praise New Morning as more than an actual New Morning, but rather as some kind of biblical Second Coming? Their prophet was back, so

they ranted and exclaimed in the papers and on the streets. Unfortunately for them, their so called prophet wouldn't be back for very long at all.

Though a massive hit and welcome return to form for Dylan at the time, these days it's often unfairly overlooked as inconsequential, too light and lacking in much depth. For me though, New Morning's subtlety is its truest strength. The almost muffled production, evident mostly in Dylan's voice, is comforting and warming. It's almost a seasonal record and for me always feels more enjoyable in the transitional phase between Autumn and Winter. The leaves are on the ground, the trees are more skeletal, and it's just getting chilly enough for the fire to come on. Yet the sun still shines, and glitters off the ground, casting shadows on the walls. The people are now wearing big coats and scarves, their heads bobbing slightly lower than usual in the cold. New Morning, now at age 31, is the kind of record I will put on when I get a moment alone. I lean back, feet up, gaze at the garden outside, the thinner yet still alive plants waving in the wind. If it was called one of Dylan's complacent "family man" albums, with its cosiness, sense of contentment and lack of social outcry, then that description fits it very well. In truth, as I get older, New Morning appeals to me more and more. The new year is on its way, itself a new morning in the truest sense. Perfect record for the man not quite at middle age yet, but one who can see it on the horizon.

Bob had received a kicking for Self Portrait and some accused him of zooming back into the studio to record New Morning as a reaction against the butchering. This of course is not true, as some of these cuts were put down during the sessions for Self Portrait, and anyone

who believes such pap really doesn't know their Dylan like they ought to. Dylan was never concerned with critical reaction to his work, or sales for that matter, and he continues to release what he wants when he wants to. Sinatra covers, Christmas albums, songs for John Lennon, etc. His has been an erratic, eccentric but consistently intriguing career. Back in 70, New Morning was just another record to him, whereas others saw it differently. Now they feel it lacks a message or a meaning, and that's funnily enough the reason I like it so much. We listen to it on its own accord, for its bare musical merit, without emphasis on social issues, Dylan's mighty lyrical influence, or the intimidating weight of the subject in question. Quite simply, it's an album full of songs, mostly short personal ones, but all honest and true to Dylan the man. In many ways, it's his purest album. He isn't living up to anything here, or living anything down. He's gone in there with some talented musicians and cut a record, then released it. What could be more pure, and indeed more Dylan than that?

The man himself summed up it all up better than anyone else could in an interview, stating, "I didn't say, 'Oh my God, they don't like this, let me do another one.' It wasn't like that. It just happened coincidentally that one came out and then the other one did as soon as it did. The Self Portrait LP laid around for I think a year. We were working on New Morning when Self Portrait got put together."

The frustrating reputation New Morning has nowadays doesn't seem to match my high personal view of it. An article like Ultimate Classic Rock's "How Bob Dylan Sorta Returned to Form on New Morning" sums up the view of it being both a rather forgettable record and also an improvement on Self Portrait. It's viewed as a step back to genius, and one towards the dizzy heights of the artistic

triumph that is Blood on the Tracks. Unlike his venomous breakup album, New Morning has an optimism to it that makes you feel good, that makes you want to get up, open the curtains and just look out at the world around you. It's positive, but not corny. That is the important difference.

Musically, I find it one of Bob's most varied and off beat albums, moments of gospel, blues, rock and singer-songwriter confession. It boasts one of the finest Dylan openers too, the marvellous If Not For You, an uplifting, bright record with a rasping vocal and tasteful musical arrangement. It sums up rather perfectly the simplicity of a strong love, and the person you rely on so much every day. It lacks schmaltziness and strengthens the love song clichés with its basic melody and purity. Surely, one of the finest love songs ever written.

Day of the Locusts is Dylan at his enigmatic best, a simple piano line leading his raw vocal take. The song tells of Dylan's experience receiving an honorary doctorate from Princeton University, and despising the whole ordeal with a passion. Despite the dark venom, the melody is upbeat and beautiful, and his hatred for the ceremony itself is not evident in the bright arrangement.

"I did something that I do to people: I got him really high," David Crosby claimed, the very man who managed to persuade Bob to collect his award. "When we got there, there was an altercation between Bob and the Princeton people, who insisted that he wear a robe. I had to convince Bob to stay and do it. There's a line that goes, 'The man standing next to me, his head was exploding.' That's me!"

"I was glad to get the degree, though," Bob wrote in his book Chronicles, obviously a little calmer all those years on. "I could use it. The very look and touch and scent of it spelled respectability and

had something of the spirit of the universe in it. After whispering and mumbling my way through the ceremony, I was handed the scroll. We piled back into the big Buick and drove away."

Stories and Dylan mythologies aside, it's another solid song on an album that gets by without needing to delve into such legendary tales. It movies on swiftly; Time Passes Slowly is a smooth, slightly encrusted interlude with thudding piano and sliding guitars. Again though, it's that voice that gets to you the most, slicing right through the mix and coming to life before and around you. Went to See the Gypsy is another muted piece, with Dylan's casual recollection of meeting Elvis Presley himself, made into an everyday exchange by the understated music around the lyrics.

The title track, for me at least, is one of the greatest songs Bob has ever written. With its simple chord structure, acidic organ and cool guitar additions, it comes into its own pretty speedily. I also love the guitar solo near the end, and Dylan's raw throated chorus never leaves your head once it's been burrowed in there.

A song like One More Weekend is like taking a time machine back to 65/66, a cool groovy blues shuffle, augmented by female backing singers, boogie woogie piano and some knife like guitar work. We've heard thousands of songs just like it with the same tempo and chord pattern, but somehow Dylan makes it an individual piece all of his own. The Man in Me is more revealing, putting a woman on a pedestal who makes him better, braver and more of a man in the truest sense by just being who she is. It's well known for its inclusion in the iconic Big Lebowski these days, but for me it's best enjoyed when within the cupboard-like, cosy confinement of New Morning.

Rather curiously my two favourites are the last two songs. They haven't always strictly been favourites of mine, but these days they seem to have become more important on the album. The lovely, spoken Three Angels is sublime and a singular entry in Dylan's discography. Its gospel tinge adds much ethereal beauty, and for me it's just too god damn short. The same can be said for the slightly surreal Father of Night, a fitting finale of piano, gospel backing vocals and wonderfully exposed Dylan lyricism.

Bob Johnston, who made solid gold with Bob in the 60s and also with the late Leonard Cohen, took a step back and let Dylan do his thing; for the most part at least, for there were opposing opinions over songs like Father of Night. Al Kooper, a Dylan legend who did some great work on New Morning, later recalled the whole thing as a hellish experience, saying, "When I finished that album I never wanted to speak to him again. I was cheesed off at how difficult the whole thing was. He just changed his mind every three seconds so I just ended up doing the work of three albums...We'd get a side order and we'd go in and master it and he'd say, 'No, no, no. I want to do this.' And then, 'No, let's go in and cut this.'... There was another version of Went to See the Gypsy that was really good. It was the first time I went in and had an arrangement idea for it and I said, 'Let me go in and cut this track and then you can sing over it.' So I cut this track and it was really good... and he came in and pretended like he didn't understand where to sing on it."

Some of Kooper's marvellous work on these sessions has now been released on the Bootleg Series' collection, Another Self Portrait, such as the brass led version of the album's title track. It's great material, and indeed, some versions are better than the ones that saw release

back in 1970. Time Passes Slowly for instance, comes more to life in the Bootleg Series, as does Went to See the Gypsy. Still, 45 years later and we are all lucky enough to hear these gems for what they are, thanks to relentless recording company repackaging campaigns.

Reviewers embraced New Morning like the arrival of an old friend presumed dead. Rolling Stone famously ran a piece which began with, "Well, friends, Bob Dylan is back with us again. I don't know how long he intends to stay, but I didn't ask him. Didn't figure it was any of my business. Put simply, New Morning is a superb album. It is everything that every Dylan fan prayed for after Self Portrait. The portrait on the cover peers out boldly, just *daring* you to find fault with it, and I must admit that if there is a major fault on the album, I haven't found it. Nor do I care to. This one comes easy, and that's what it's all about, isn't it? A newly re-discovered self-reliance is evident from the first measure to the last fadeout, the same kind of self-reliance that shocked the old-timers when this kid dared to say 'Hey-hey Woody Guthrie, I wrote you a song.' That may have been his own modest (as it turns out in retrospect, anyway) way of saying 'Here I am, world.' Calling his latest outing New Morning may very well be his way of saying, 'I'm back.'"

The album did cause a slight backlash too, though the notices were positive. There were no prophetic statements here, no shamanic words of wisdom to lead his followers in the right direction. What these Dylan obsessives forgot though, is the fact that he never sang to gain their devotion in the first place; he sang for himself and ended up picking them up along the way, a bit like the reluctant messiah in Monty Python's Life of Brian. As for the rumours of this being a speedy follow up to win bag his doubters, it's utter poppycock. Bob

had merely gone back into the studio at Columbia, New York, at the very start of May, wishing to lay down some more numbers. After all, Went to See the Gypsy, Time Passes Slowly and If Not For You had all been recorded for Self Portrait, but he scrapped them and started again. He then had a laid back studio jam with George Harrison, recording a few covers, which are now available on bootleg and are very good indeed. Bob went on to cut some more tracks in June, and overdubs were done at the end of July. This was no hurried reaction against Self Portrait's massacre at all. This was business as usual.

Those hoping for a return after Dylan's rather muted three years, or heaven forbid *a tour*, would be slightly deflated to learn that he wouldn't release another record for a few more years. There were legal fall outs in this period with his manager Albert Grossman and he would be largely out of the public eye until the middle part of the decade. It was to be his most reclusive era. For me, this aspect of New Morning is rather interesting. He came back with this downplayed, quiet little album of curious oddities, some very typical of Dylan and others unusually not so, but didn't follow it up a year or so later with a new album, as he had done since the start of his recording career. He waved his hand and went away again. He did resurface briefly for his monumental appearance at George Harrison's Concert for Bangladesh, recorded with the late Leon Russell in 71 and released the protest single George Jackson the same year. But nothing else came forth. It became something of a cliché that Dylan was out of view in the rock landscape of the early 1970s. They said they needed him now more than ever, but he wasn't interested. New Morning was his statement; no mention of Vietnam, social disorder, or the drag of the end of the sixties. Just an album of songs, no more, no less.

GREATEST HITS 2

The two words Greatest Hits are usually a nightmare for any serious artist. Having their work gathered together with a view of finding the best bits is like creative castration. After all, songs were made to fit together on a record for a reason. They had a flow, they blended together and fit side by side. They were meant to be that way forever. So a compilation of hits, especially to someone like Bob Dylan, seemed a pointless entity. A volume 2 was an even bigger kick in the balls.

The first Dylan "best of" had come out back in 1967, and had become his highest selling record of the 1960s. It featured such massive, monumental cuts as Blowin' in the Wind, The Times They Are a-Changin' and Like A Rolling Stone. It was basically the singles, the "hits" as the title suggests, but most fans would agree not a best of collection by any stretch. Some of the album cuts by far exceeded the

well known material, but the collection was a good way of compiling all of Bob's best unknown anthems and stacking them aside each other to see the full weight and variety of his song writing in a mere five years or so.

Four years later, volume 2 hit the shelves, originally released to capitalise on Dylan's high profile appearance at Harrison's Bangladesh shindig. This time, Dylan's best was given four whole sides of vinyl and for me at least is a stronger collection than the first. Though missing anything from New Morning, it had key cuts from a number of classic albums, and most importantly some new and previously unreleased stuff too. The opening Watching the River Flow, a 1971 single for Bob, is a stonking opener, but the set soars throughout, going all the way back to 63 for Don't Think Twice (It's All Right) and the unreleased Tomorrow Is A Long Time. Though the more familiar likes of Lay Lady Lay are welcome additions, it's in the newer stuff you get the most entertainment.

For some of the new tracks, Dylan called in an old buddy. Musician Happy Traum had been a friend of Dylan's for some time. "I was first introduced to Bob in 1962 by our mutual friend, Gil Turner," Happy himself told me in 2015. "I don't remember precisely, but it's possible that our first meeting was at Gil's apartment, at a party where we were all sitting around swapping songs. Some underground tapes were made that day that have long been called The Banjo Tapes. I remember Bob singing If I Had to Go It Again I'd Do It All Over You, as well as a song that has since been covered several times, I'm A-Walking Down the Line. Please note that my chronology might be off a little. It's been a long time... I had moved to Woodstock, NY with my family in 1966 and Bob lived right up the road from where we

were staying. He was recuperating from his accident and was keeping a low profile, but he remembered us well from our NYC days so we became reacquainted and good friends. We played music together at his house and at mine, our kids played with his, and we spent quite a bit of family time together."

Then out of the blue, Dylan picked up the phone in 1971.

"One day, in 1971, he called me and asked me if I would come into New York City with a banjo, a guitar and a bass," Happy recalls. "So, of course, I took the bus to New York with all my gear and met him at the Columbia Studios. As I remember, Bob and his family had recently moved to the city and he was living on MacDougal Street. It was an evening session. Bob, the sound engineer and I were the only ones in the building. We recorded four tracks, three of which later appeared on his Greatest Hits, Volume 2 album. The fourth one, Only a Hobo, came out just last year, on Bob's Another Self Portrait box set."

"That studio session was very relaxed and friendly, just as it was when we played together at home," Happy continues. "Although I was aware of the potential importance of the sessions, I was able to put that behind me and just have fun. We didn't do more than two takes of any song, so it was very spontaneous. The only thing that wasn't live was my bass part on You Ain't Goin' Nowhere, which I overdubbed. I had no idea whether any of those songs would ever see the light of day, so I was really delighted when they actually appeared on his Greatest Hits compilation."

Traum played guitar on a solid run through of I Shall Be Released, a song that was by then already familiar to bootleggers and fans of The Band. They had cut it on their debut record, and Dylan and the boys had also gone through it on the famous Basement Tapes, yet to be officially released at that point but heavily bootlegged as The Great White Wonder.

"I had known this song from The Band's Big Pink album," Happy said of the song, "as well as from the much rougher Basement Tapes, and I always loved it. Like everything else, Bob put his own stamp on the song, and when we did it in the studio it just came out in a new way. I like to think that I contributed to the feel of it with the way I played my part on the guitar and sang my vocal harmony."

My personal favourite track on Greatest Hits 2 is the raggedy version of you Ain't Goin' Nowhere, itself a track famously covered by The Byrds. This two man rendition though, is fantastic, with Dylan and Traum working together quite beautifully. I put it to Happy that this had been a favourite of mine since I was a kid.

"I have to add that this is one of my all time favourite things I have done in my career," Traum says with pride. "I never get tired of

hearing this version of the song and I'm extremely proud of the way it came out. To me, it has a joyous spontaneity and a great groove that just makes you want to tap your feet and sing along. I'm pretty sure Bob likes it too. To me, Bob is on a pinnacle all his own. I can think of more accomplished guitar players, smoother singers, maybe even better pop songwriters, but I can't think of anyone who comes close to delivering the whole package he has always given us. For me he stirs emotions, especially in his earlier work, that no one else can touch. I'd much rather hear Bob sing his songs than any of the "better" singers who have recorded them. And he's still putting it out there all these years later!"

Reactions were good to the loose structure of Greatest Hits 2, with many applauding the inclusion of lesser known Dylan cuts. "Yet another self-portrait," Robert Christgau wrote of the album. "With all of Dylan's overexposed stuff relegated to Volume I, it unlooses one indubitable classic after another, and because it spans a decade without pretending to (or bothering with) thematic/stylistic coherence, the only overall impression it creates is a staggering, unpredictable virtuosity."

Never has a critic been so correct...

AJ WEBERMAN VS. BOB DYLAN

"That's some sneaky shit man," says Bob Dylan during the infamous January 1971 phone conversation with garbologist and Dylan fanatic AJ Weberman. The reason Dylan is so hostile is because Weberman - little more, at first, than a curious obsessive who Dylan kept close by for a brief time to see what he was all about - is because he taped a conversation they had, transcribed it and sent it off the to various underground papers under the misleading pretence that it was a proper interview. "Dylan speaks!" etc. But Dylan was pissed big time. "If you want to have an interview, we can have an interview," Dylan says, his iconic and familiar tones becoming more nasally and agitated. "But do it above the table. I think I deserve that right."

The tapes of these conversations have been made available a few times, and are essential listening for anyone interested in Dylan's early 70s phase, when he moved to Greenwich Village and attempted

to live a "normal" life. Once Dylan read the sleazy transcripts three days later on January the 9th, he spoke to Weberman again, and was even more irritated. The call becomes increasingly hostile between both men, with Dylan especially getting very irate. Weberman had been a fan, but had begun to write negative articles on Dylan when he believed his former idol had become a romantic crooner of love ballads. He says Dylan had become complacent, a rich rock star no longer concerned with the little people or important social issues. John Lennon, recently arriving in New York, was out and about doing all kinds of benefit concerts and skirting on the edge of the law. Weberman felt Dylan was slowly drifting out into irrelevancy.

The calls are not only entertaining for a Dylan fan, but they are also important social/historical documentation of the relationship between fan and star, or perhaps super fan/mad man and star. The tapes are also evidence of how a fondness can become a dark, twisted obsession. Clearly, Weberman crossed a barrier long before this chat, but to Dylan's credit, he doesn't think to just slam the phone down, as many other men might have done. He amuses himself, at Weberman's expense of course, and sticks around just to see what the man will lower himself to next. Dylan was an observer, and who better to observe than a creepy obsessive like AJ?

AJ was a college drop out who got totally infatuated with Dylan, and then started going through his rubbish at his MacDougal Street apartment. Dylan had fled Woodstock, fed up with the constant attention, the unwanted visitors and those searching for the answers. They'd camp outside, enter his home, hound him endlessly. For some reason, Dylan thought that moving to the city with his wife and

children would result in a quiet life. He didn't bargain for AJ Weberman!

"So we couldn't breathe," Bob said in 1984 of the situation in Woodstock. "I couldn't get any space for myself and my family, and there was no help, nowhere. I got very resentful about the whole thing, and we got outta there. We moved to New York. Lookin' back, it really was a stupid thing to do. But there was a house available on MacDougal Street, and I always remembered that as a nice place. So I just bought this house, sight unseen. But it wasn't the same when we got back. The Woodstock Nation had overtaken MacDougal Street also. There'd be crowds outside my house."

The worst aspects of AJ's Dylan fanaticism were the ludicrous, offensive lies he made up about him. While coming up with secret codes behind Dylan's lyrics, and what they "really meant", AJ became convinced that Dylan was also a heroin addict. He even taught Dylanology classes to other strange assorted odd balls, and one infamous night took them down to Bob's home to stage a vile protest.

The weirdest thing about all this is that 45 years later, Weberman is still writing nonsense about Bob, some of it very sick indeed. His recent titles include The Devil and Bob Dylan, which suggests our man made a pact with Satan himself. Another plain odd title to spew from AJ's typewriter is Gentleman Junkie, all about Dylan's heroin addiction, which AJ claims is still ongoing to this day. It's baffling, truly baffling. While Dylan is getting plaudits like the Nobel Prize, topping the charts with new albums and touring the world constantly, the man who drove Dylan out of Greenwich Village is still writing drivel about one of the most important and iconic figures in history.

To Dylan's credit, he made sure that AJ got what he deserved. "I'd agreed not to hassle Dylan anymore, but I was a publicity-hungry motherfucker," Weberman told Rolling Stone years later. "I went to MacDougal Street, and Dylan's wife comes out and starts screaming about me going through the garbage. Dylan said if I ever fucked with his wife, he'd beat the shit out of me. A couple of days later, I'm on Elizabeth Street and someone jumps me, starts punching me. I turn around and it's like -- Dylan. I'm thinking, 'Can you believe this? I'm getting the crap beat out of me by Bob Dylan!' I said, 'Hey, man, how you doin'?' But he keeps knocking my head against the sidewalk. He's little, but he's strong. He works out. I wouldn't fight back, you know, because I knew I was wrong. He gets up, rips off my 'Free Bob Dylan' button and walks away. Never says a word. The Bowery bums were coming over, asking, 'How much he get?' Like I got rolled... I guess you got to hand it to Dylan, coming over himself, not sending some fucking lawyer. That was the last time I ever saw him, except once with one of his kids, maybe Jakob, and he said, 'AJ is so ashamed of his Jewishness, he got a nose job,' which was true -- at least in the fact that I got a nose job..."

The showdown would signal a big turn around in Dylan's life. Being hounded by people like Weberman showed that fame was intentionally very dangerous. It also made him close the doors on the world, retreat further into himself and become even more private than ever. Dylan was definitely on to something here. Consider his one time friend John Lennon's fate at the end of 1980 in the same city. Dylan could have wound up the same way had he stayed so approachable, vulnerable and exposed. Though he had tried his best, Bob Dylan could not live a normal life.

THE DYLAN ALBUM

The reaction Self Portrait garnered with its odd ball cover choices and strange Dylan vocal style seemed like nothing compared to the ones earned by the curious 1973 release, titled simply Dylan. Put out by Columbia without Dylan's approval, it's an album that has been utterly side lined in the great man's discography ever since it farted out of the label. It's definitely his most unappreciated work, and that's saying something when you consider the hammering of his 80s work. Indeed, as much as Self Portrait had divided fans and critics, in time it has seen a reappraisal of sorts due to the fantastic archival Bootleg Series entry, Another Self Portrait.. Yet it is still not fully embraced in its original form. This one however, makes Self Portrait look like Blonde on Blonde in the eyes of Dylan fans. For me, quite perversely to others, I think it's a record with a lot going for it. Yes it's crusty and

slightly slap dash in production and presentation, but there are aspects of this cobbled shambles that I really appreciate.

When I was first collecting Dylan vinyl, it was an exciting treasure hunt. Sure, I could have nipped on to the eBay and snapped them all up speedily, soullessly obtaining the entire collection in mere minutes. But I wanted to do it the old fashioned way, tracking them down in the racks of foisty old record stores. I had seen this rather garish cover of a record just called Dylan, and as I had never noticed this item in the CD racks, or mentioned in articles or books very much, if at all in fact, I always found it rather baffling, like a repackaged bootleg, possibly the Basement Tapes again. When I started to learn more about Dylan's vast catalogue, I learned the truth about it. Then, inevitably, I saw what people had to say about it, so I left it for a while, in the rack of one particular record shop where it never seemed to leave. I kept going back, eyeing it briefly, then going on and getting something else. One day, I thought 'Sod it', picked it up and had a look. Why not? Can't be that bad. You never know, I might really like it. After all, you can't believe every review you read. The album grew on me very quickly, its odd ball song choice and poor production appealing to my love of the obscure from the word go. But why? Surely, this was a half assed collection of covers and outtakes from what Clinton Heylin called the least interesting period of Dylan's career. But I was destined to enjoy this one. I always disagreed with Clinton's assessment of this time in Bob's career and I for one am endlessly fascinated and drawn back to the 69 - 71 sessions.

The 73 Dylan album has never been put out as a stand alone official CD in its own right, included in a Dylan boxed set but never

given a standard release. There are iffy copies floating about the place if you look, but for me, it's always got to be the vinyl version. Putting it on the player, placing the needle down and hearing the first crackles seems to make it a more special experience. And with the ramshackle quality of the record in question, it also makes it more of an exciting experience, as if you've found an old acetate, unmastered and forgotten, hearing it before everyone else. The truth however is dramatically different. This is a widely despised record, sneered upon by critics and hated by most fans. Weirdly, and I am not so sure why, I just love it. Maybe I'm one for the underdog.

Rolling Stone, usually on Dylan's side - even through the "worrying" hick/country phase - slaughtered the album viciously, and pulled no punches on Bob. "Columbia has a right to release unissued material by its former employee, Bob Dylan," they ranted. "And I personally want to hear most of it, especially outtakes from the pivotal acoustic albums and the concert recordings. But I can't understand why the label has begun what will inevitably be a long series of "new-old" Dylan LPs with rejects from Dylan's weakest album, Self-Portrait. Bad as Dylan is, it provides no basis for new criticism. It contains only those flaws in evidence on the earlier work, namely the bizarre choice of material, insipid, incompetent production and erratic and uncontrolled singing. As with Self Portrait, there are rewarding moments in passing, most notably on A Fool Such As I (done in his Nashville Skyline voice), The Ballad of Ira Hayes and Can't Help Falling in Love. But, Mr. Bojangles, Sarah Jane and Big Yellow Taxi (an utter disgrace and one performance that Columbia should have had the good taste to withhold) are so bad that they inevitably re-pose Self-Portrait's central question: What was Bob Dylan thinking

about when he sang this stuff? We'll never know, so we're best off waiting patiently, knowing that Ceremonies of the Horsemen will surely be better than this inept package of a great artist's weaker moments, best left forgotten."

The mentioned album in planning, Ceremonies of the Horsemen, was the supposed title of Dylan's next studio album, but it was changed to Planet Waves, which came out to good notices the following year. Dylan, even by then, was completely forgotten, buried and neglected like an unwanted mutt. Though it reached number 7 on Billboard and ended up shifting half a million units (pretty good really for a frazzled little outtakes album, and indicative of Dylan's commercial clout), Dylan was disowned by the man himself and drew the reputation of a stinker. At the time, Bob was shifting over to Asylum Records, and relations with Columbia were at an all time low. Contractual shuffling and management changes resulted in a fine mess, and this clumsy, poorly promoted record. Anyone who has seen the poster for A Fool Such As I, the single released from the record, can see this was a sick joke on the part of a bitter Columbia. Dylan peers at the camera like a murderer, not so thrilled with the release, and telling us all so with an intimidating stare. Bob clearly hated the album and wanted nothing to do with it. It was simply cheap exploitation, releasing a collection of unwanted scraps just as their biggest artist was passing over to a new label, and represented the worst side of the traditional record label. Even on a non-musical level, it's no great mystery why Dylan would hate the album. Yet I wonder how he might feel about it now, all these years on, if he ever sat and listened to it. But that is never going to happen, so I must press on.

It's well documented that the tracks here are culled from the Self Portrait and New Morning sessions, and as New Morning is one of my personal favourite Dylan records, anything that came from those recording dates was always going to appeal to my curious love of this period in Bob's career. I know I'm out there alone in a vast wasteland of nothingness (here is an album often ignored completely in books on Bob), but this record gives me a strange warmth. I know... someone call a doctor.

His fast paced, outlaw western tinged version of Lily of the West is sublime, a traditional song given the Dylan treatment. It would have fit on the soundtrack for Sam Peckinpah's Pat Garrett and Billy the Kid just nicely, the very film which, of course, featured both a soundtrack and acting role from Dylan himself. I am not sure if any real Dylan admirer would honestly have a hard time with this song, for it features a charismatic, effortlessly cool Bob vocal and some nice female back up. It has that particular Self Portrait oddity to it, perhaps explaining why it's not so popular with fans. The harpsichord which dances along the mix is a nice eccentric touch, but the real focus is on Dylan, who recalls this western tale with exuberance, adding an air of cinematic intrigue.

Though he abandons the familiar melody so finely conveyed by his hero Elvis Presley in his iconic rendition, Dylan's cut of I Can't Help Fallen In Love With You is transformed, rather nonchalantly, into something different entirely. Bob eases into it so naturally that you might be fooled into thinking he'd penned it, if of course you hadn't heard the King's legendary version. Painfully underrated, this has to be one of Dylan's finest studio cover versions. For a man so well known as the finest songwriter of our times, he's done a remarkable

amount of covers both on stage and in sessions; some appreciated, others less so. This one falls in the latter category, the supposedly bland, corny Self Portrait sound. Personally I adore Dylan's rough vocal, the sweet harmonies, the bass/acoustic simplicity and the wonderful harmonica solo towards the end. Replay it, and maybe reconsider this isn't so bad after all.

Sarah Jane is appallingly produced, one cannot deny it, but it has a charge to it that brings to mind the Pat Garrett soundtrack. Bob's vocal is sturdy, while the female backing props him up solidly. The cut is almost ruined though by the shoddy production, which sounds third generation and terribly muffled.

Dylan's take of The Ballad of Ira Hayes is beautiful, and one wishes it could have been placed on New Morning. Buried as it is on this obscure oddity, it's a shame that few people will get to hear and enjoy it for what it is. Bob's compelling take on the words is very stirring, both the spoken section and the wailing chorus. There's some lovely weaving going on in the background, a musical mesh of organ, piano and backing vocals, giving it a gospel touch.

Few would claim to be even remotely fond of Bob's recording of Mr Bojangles, a song made to be sung by a more, how can I say this... conventional singer. It's not his best moment, a song unsuitable to his vocal style, but it's not that bad, or certainly nowhere near as bad as people would have you believe. The traditional Mary Ann is not dissimilar to vintage early 60s folk Dylan, save for the backing vocals and understated musical backing. In his voice and mood though, Dylan sounds like he could be back in 61 or 62, one of countless young singers to cover the folk standards. It's effective stuff and fits Dylan's tones perfectly.

His version of the Joni Mitchell classic Big Yellow Taxi is roundly detested and is seen as a very misguided choice for Bob, but I honestly think it has its charms. The organ run, female backing and nice bouncy rhythm section mix together sweetly, even if Dylan has altered the vocal melody to fit in with his approach. For me, it works and is a nice way of Bob doffing his cap to one of the masters. Not that she'd be doffing her cap back at him. In a recent interview, Mitchell said, "Bob is not authentic at all. He's a plagiarist, and his name and voice are fake. Everything about Bob is a deception."

Moving on to A Fool Such As I, and Dylan is doing his weird Self Portrait voice, the one he stunned fans with at the 1969 Isle of Wight performance. It's not the Dylan we all know, but the music has a real infectious groove to it and Bob keeps the tune going nicely. The final cut is Spanish is the Loving Tongue, a gorgeous run through the 1907 poem by Charles Badger Clark. Beautifully sung by Bob, it's a subtle, bare and honest recitation of the fine piece.

It becomes clearer that in its brief running time and nine mixed tracks, Dylan isn't such a bad album at all. I can sure see why people might have their problems with it, but for me it's a nice collection of Bob outtakes we are better off having than not. With more of these sessions unearthed in the marvellous Another Self Portrait release, and getting a good reception, it could be that Dylan's followers are becoming more open to this lost era of his career.

It's hard to find a good review of this record though, and again, checking my Dylan books, it only ever gets a passing mention most of the time, mixed in with the sections covering the complex contractual issues with Columbia and Asylum Records. Robert Christgau's review seems to match most people's view of the album.

He wrote, "Listening to this set of rejects from what used to be Dylan's worst album does have its morbid fascination - if you'll forgive the esoteric reference, it's like watching Ryne Duren pitch without glasses. Not only are the timbre and melody off -- he was always wild -- but he also doesn't phrase cogently, and the songs just hit the dirt. All of which is CBS's punishment after Bobby had the bad manners to sign with another label. I wonder how he could imagine that Columbia is less than benevolent." Entertainment Weekly, rather hilariously, called it simply a "gruesome collection of Self Portrait outtakes."

So I'm on my own here, but what is the point of this piece? Well it's to point out that not every album has to be a prophetic grand statement, that even Dylan can be mediocre or light, and still be valid and enjoyable when being so. The truth is that these recordings are no worse than what a lot of his contemporaries and other singer-songwriters were putting out at the time, but we had been expecting so much, too much in fact from Dylan that anything unlike the speed freakery of Blonde on Blonde and Highway 61 was going to a disappointment. People couldn't seem to understand that Bob didn't wish to be a voice for the people, and definitely didn't want to repeat himself album after album. He wanted to press on, experiment, try new things and play around, even if he didn't want it all released. Ron Cornelius claimed that Bob told him that during the Self Portrait sessions he had around 400 songs in his head, just swimming around all the time, waiting for their turn to step forward. That said, Dylan was not short of material and his choice of odd ball covers seems not only perverse, but eccentric too. Dylan was and is his own man, so let's love him for it; and while we're at it, give this another spin.

PAT GARRETT AND BILLY THE KID

"It is every bit as inept, amateurish and embarrassing as Self Portrait. And it has all the earmarks of a deliberate courting of commercial disaster, a flirtation that is apparently part of an attempt to free himself from previously imposed obligations derived from his audience." - Rolling Stone Magazine, 1973

When considered, the 1970s really were a bizarre and mixed time in Dylan's career. He'd not made a studio record since 1970s dual attack of Self Portrait and New Morning, had made infrequent live appearances (Concert for Bangladesh) and only put out the odd single, such as 1971's protest song George Jackson. This was a quiet time for Bob and in his absence, other groups and artists were filling the void, though it was arguably a case of style over content. Led Zeppelin were bringing heavy rock to the world, Bowie was giving it some theatrical pizzazz and T Rex and co. were bombarding the charts with fun but inconsequential glam rockers. Other than that,

there seemed to be very little of substance, no leaders or people to turn to. The Beatles were long dead, the sixties were over, McCartney was a rock superstar with Wings and John Lennon had disappeared to New York and for some time, up his own back side. Dylan too was out of the limelight, slipping from the minds of music fans and critics. But Bob was still there, he just didn't need to be naked in the full beam of the world's spotlight anymore. He was painting, writing, and as it turns out, cutting music for a Sam Peckinpah movie, a movie which he would end up acting in.

Screenwriter Rudy Wurlitzer asked Dylan to write a song or two for the movie, though Peckinpah, apparently unfamiliar with Bob's work and legendary status, needed some convincing. "Rudy needed a song for the script," Dylan said in 1973. "I wasn't doing anything. Rudy sent the script, and I read it and liked it and we got together. And then I saw The Wild Bunch and Straw Dogs and Cable Hogue and liked them. The best one is Ride the High Country. So I wrote Billy real quick." Dylan sang Sam his new tune, and quietly convinced the eccentric mad man director that he was the perfect choice for adding music to his new film. He then offered Dylan a role in the picture and soon the character of Alias was drawn up, though the purpose and point of the character was never arguably that well defined. Still, even though the film's cut is messy and is said to be a shadow of Peckinpah's original aim, it's a rustic, gritty western, taking the glamour out of the old Wild West movies, focusing on the dirt, excess, sex and blood. Dylan, quite expectedly given his mystique, is quietly brilliant as Alias. Unusually understated and moody, one wonders how much of this was performance and how much was naturalistic. Kris Kristofferson, the film's lead, said that Dylan was

painfully reserved on set, as did James Coburn, who called him "a strange cat, a wonderful guy."

Cutting the music for Pat Garrett wasn't entirely easy for Bob. He had never done film music before, and holed up in a studio in Mexico City with an array of assorted musicians, Bob felt out of his comfort zone. Peckinpah's usual movie scoring composer, Jerry Fielding, was venomous about Bob and dismissive of his musical abilities. Everyone else applauded Dylan's work but Fielding, who came across as out of touch and irrelevant. But one cannot see what Fielding had trouble with, at least musically. Sure, an old fashioned movie scorer like Fielding would fail to get the off the cuff, spontaneous magic of Dylan's mode of recording, but how could anyone truly not be impressed by a song like Knockin' on Heaven's Door? When the track became a Top 20 hit and helped boost the film's profile, Fielding, who had called the song shit, looked rather silly indeed.

Elsewhere, Dylan's incidental film music, though very simple and lacking in frills, captures the grimy, sandy Western like few other movie scores could hope to. Ennio Morricone's dramatic and iconic scores for the Sergio Leone Westerns were exotic, enigmatic and catchy as hell, and just as important an ingredient to those films as Clint Eastwood was. Dylan's score is subtle and understated, yet something about it feels sincerely genuine. The repeated Billy theme which comes and goes throughout the movie should really, by all rights, start to feel repetitive; but it doesn't. Dylan's straining voice somehow defines the desperation and nothingness of this landscape. Matching Peckinpah's view of endless scenery and lifeless valleys, Dylan's music is the epitome of a fading dream, this dream giving way to the bloody death of the Old West.

Reviews were mixed though, and many of them fell in the familiar camp of disappointment at the fact that their prophet, their sage, their messiah, had supposedly drifted into irrelevancy. Rolling Stone were one of the loudest criticisers of Dylan's score, writing, "Pat Garrett and Billy the Kid is reminiscent of Another Side of Bob Dylan, but only in its rambling rhythms and undisciplined and flat vocal style. It doesn't contain any of the earlier work's redeeming emotional freedom and sense of abandon. And his harmonica playing is at its worst, another small sign of the album's almost wilful badness, which is as mysterious as it is confounding to those who respect his past accomplishments. It is ironic that the most significant white rock figure of the Sixties has turned himself into one of the least significant of the Seventies. But the most perplexing aspect of it all seems to be the deliberate intent behind the decline. I can think of no other way to explain the gap between the man's earlier accomplishments and the recent dissipation of the quality of his work. But whatever the explanation, one can only note with sadness that in the midst of the summer morass of predictable popular music, Bob Dylan has once again broken the mold, only this time, with the least acceptable method available to him, an album neither exceptional, nor truly different, but merely awful."

The movie itself was met with initial hostility too, although over time it gained popularity. The released cut was less than satisfactory, and cast and crew alike were sorely disappointed by it upon first viewing. "The MGM cut really blew my mind, it was really fucking terrible," said James Coburn. "It made me sick, after all the anguish of making the fucking thing."

"The time is 1881 and, at least according to Peckinpah's The Wild Bunch," hissed Vincent Canby, "there were outlaws and drifters still carrying on as late as 1913. This is not terribly important in itself, only to emphasize the surprising phoniness of his new endeavour, which sounds like an album called The Worst of Bob Dylan. Mr. Dylan not only appears in the film, sort of hesitantly, as a retarded hanger-on to Billy the Kid but he also wrote and sings the soundtrack score, which does not include The Times They Are a-Changin'. The music is so oppressive that when it stops we feel giddy with relief, as if a tooth had suddenly stopped aching."

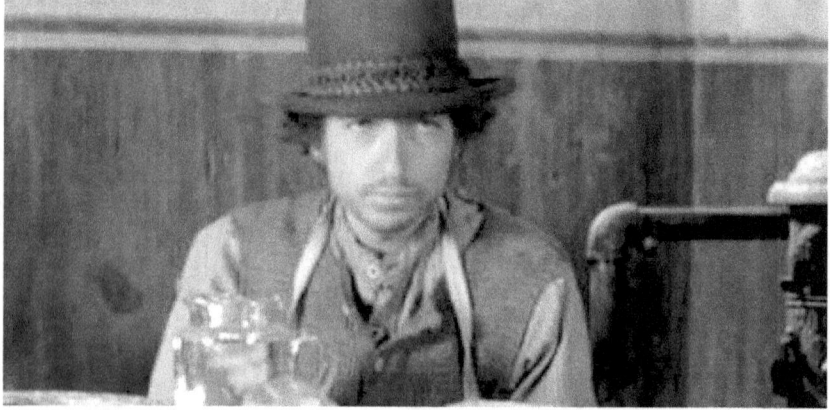

"Bob Dylan plays a character named Alias, and should have used one," Roger Ebert wrote. "His screen presence makes him look as if he's the victim of a practical joke involving itching powder. Two scenes in particular remind us of the Peckinpah vision: One when Garrett and a man on a river board accidentally begin a meaningless exchange of shots, and another when Garrett waits on a porch swing for Billy to finish making love before he kills him. Otherwise, the movie fails to work up much excitement, and the title song by Bob Dylan is quite simply awful."

The criticism Dylan received for both his acting and music in the film is perhaps best explained when you consider the time this project was released. After all, Bob Dylan was considered yesterday's news in 1973, a figure of the past and someone who personified the wide eyed, and hopelessly naive optimism of the long dead 1960s. Any music he made was inevitably compared to his mid 60s electric folk rock work and his early acoustic albums, while any film appearance was no doubt going to be judged against what many saw as his ultimate film performance, in DA Pennenbaker's Dont Look Back, as a warped version of himself. The truth is that Dylan gives a very intriguing and interesting effort as Alias, calm and measured, rather like his performance in 2002's weird and wonderful Masked and Anonymous. Dylan is clearly a musician dabbling in acting, so anyone expecting a tour de force of every dramatic scale is going to be disappointed. But it's a great little role and Bob does it well.

Even the legendary Dennis Hopper was impressed, telling Mustard Mag, "Have you seen Dylan in Sam Peckinpah's Pat Garrett And Billy The Kid? He's so fucking good in that movie. That scene where he's reading the labels on the cans while James Coburn's setting about Billy's allies – I tell ya, that stuff's really fucking hard to do. I'll be honest, I haven't seen all of Dylan's movie work. I hear some of it's pretty rough. But seeing him in Peckinpah's movie, I never felt I was watching a rock star trying to be an actor. He just seemed really, really natural, and that's all you can ask for in an actor. Peckinpah certainly liked him – and he hated everyone, Sam! And as great as Kris Kristofferson is, I often wonder what Pat Garrett And Billy the Kid would have been like with Dylan as The Kid. Pretty good, I reckon."

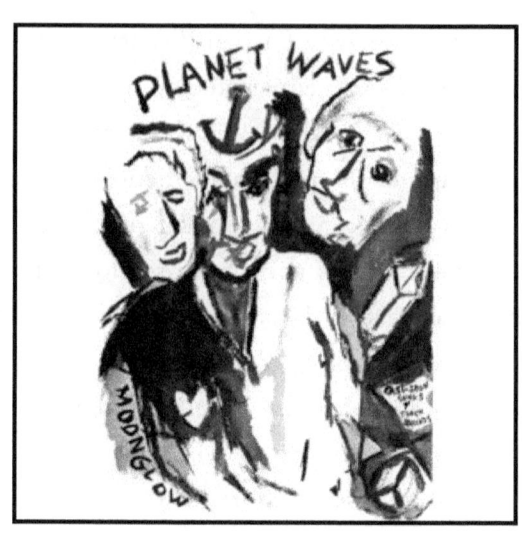

PLANET WAVES

Planet Waves, in theory, should really be widely remembered as Dylan's great comeback album. After all, this was his first new LP of original material - save for the low key Pat Garrett soundtrack - in four years, since the initially praised New Morning in 1970. Had Bob not gone on to follow Planet Waves with one of the finest records of the 20th century - Blood on the Tracks, of course - I feel that it would be seen as one of his biggest triumphs, post bike crash. However, as it stands, it's a solid record, but one largely seen as a stepping stone towards greater goals. Planet Waves is a strong album in its own right, unfairly overlooked by biographers and Dyalnites when attempting to make a tidy map of his long and winding career. In all fairness to Planet Waves, it is best enjoyed when just taken on its own terms. Ignore the gold around the corner, the heartbroken perfection of Blood on the Tracks, and enjoy this for what it is; a damn fine

record by Bob Dylan, backed by The Band. It was also his first Number One album in the US, no less.

With a scratchy, surreal piece of cover art by Dylan himself, the comparisons with Self Portrait end right there with the sleeve. The songs here are originals, all are strong, and some are among Dylan's finest ever work. From the moment it begins with his jolly, upbeat On A Night Like This, this mix of moods and styles is among Bob's most consistently flowing records. It was the first properly released album by Dylan and The Band together. He had toured with them in the mid sixties of course, with the early Band acting as Bob's back up group in those heady, speedy days. In 67, they had made some legendary basement noise together in various homes around Woodstock, but wouldn't get into the studio properly to cut an actual record until 74. In 1975, Bob was to comment to Patti Smith that he wished he had kept one solid band going for himself, a reliable back up group with whom he could share a solid camaraderie. Though he had used countless musicians on his records since 1965, The Band were the closest to being Dylan's regular gang. While the acclaim inevitably goes to The Basement Tapes in regards to their musical collaborations, Planet Waves is definitely worthy of more credit.

Beginning messily with a hurried strum of the guitar, the group come bouncing in together with Bob's creaky voice, on the sublime On A Night Like This. There's a ragged energy to the music, with a thumping bass line and energetic accordion, that is infectious, but Bob's lyrics and raspy vocal is totally centre stage. The last time we heard him on one of his conventional studio LPs, he was fading us out with Father of Night, backed by the choirs at the closing of New Morning. On A Night Like This heralds a true new morning, more

literally this time, as classics were to follow imminently. It feels like a fresh jump start to Bob's flaming recording career. The three minute joy of the album's opener is the beginning of one of Dylan's most remarkable runs as an album artist.

Going, Going, Gone has another appealingly messy start, as if we're back in the basement as the group are just cooking up after a beer break, but it soon eases itself into one of Dylan's smoothest and neatest tracks. With fine musical accompaniment by The Band (in particular those Robertson licks and the holy organ), there is still enough space for one of Bob's greatest melodies. There's a flow to the song here that is both soothing and, not to over praise things, a touch of genius. It's so understated, like much of his work, that it's easy to overlook Dylan's knack of putting together a crafty, perfect chord structure. The true magic here is the river of notes flowing to Bob's recitation of the song's title, and his voice is floating and seamless too. For an artist whose albums are often described as unmusical, and so focused on words alone, this is remarkable music. It's partly thanks to The Band's pitch perfect ensemble arrangement, but this is Bob's song, and pretty close to perfection.

Tough Mama has a satisfying tight crunch to it, with ranting harmonica and guitar duelling together at the start. Bob wails and soars vocally, while the band are as steady and stable as ever. Hazel is more blissful, a slowed down number with a beautiful chord pattern and sweet Bob vocal performance. Again, it's in the colourful accompaniment where the song comes into its own, with classic Robertson guitar and legendary Levon Helm drum patterns. It has all the dazzle of The Band's best work (in particular the uplifting sounds of the Last Waltz concert), while they paint Dylan's canvas

with more exotic, varied shades than it's used to. There is a rich musicality to this which separates it from much of Dylan's more jagged, brutal and proto punk approach.

Something There Is About You is a wonderful tribute to love itself in its simplest form, of flowing hair and nostalgia from another century. Dylan, or the character he is masquerading as, sounds misplaced, longing for a simpler, more romantic age. The chords flow sweetly, with funky back up (all groovy guitars and keyboards) and a smooth vocal where every word, each syllable, is clear as day.

Undoubtedly though, the stand out song here, and one which has lasted and become an iconic anthem, is the remarkable, powerful, flooring and utterly perfect Forever Young. Supposedly a song for his young child, Bob sings his heart out, hoping for the best in this world for his innocent kin. The drums are sturdy, and without unnecessary frills, only really taking off in the chorus and at the closing. There is an under stream of organ, gently flowing, and subtle guitars and bass. There is little else going on, and all is kept sparse to clear the way for one of Bob's most moving set of lyrics. His performance seems true, totally sincere and seemingly more involved in the song's sentiment than ever before. There's a sense of instinctive wizardry too, this being of the breed that could only have been captured once. Funnily enough, it almost didn't make the record.

"We only did one complete take of the slow version of Forever Young," the album's producer Rob Fraboni later said. "This take was so riveting, it was so powerful, so immediate, I couldn't get over it. When everyone came in nobody really said anything. I rewound the tape and played it back and everybody listened to it from beginning to end and then when it was over everybody sort of just wandered out

of the room. There was no outward discussion. Everybody just left. There was just a friend and I sitting there. I was so overwhelmed I said, 'Let's go for a walk.' We went for a walk and came back and I said, 'Let's go listen to that again.' We were like one minute or two into it, I was so mesmerized by it again I didn't even notice that Bob had come into the room. So when we were assembling the master reel I was getting ready to put that take on the master reel. I didn't even ask. And Bob said, 'What're you doing with that? We're not gonna use that.' And I jumped up and said, 'What do you mean you're not gonna use that? You're crazy! Why?' Well, during the recording, Dylan's childhood friend Lou Kemp and this girl came by and she had made a crack to him, 'C'mon, Bob, what! Are you getting mushy in your old age?' It was based on her comment that he wanted to leave that version off the record."

Thank god Bob was persuaded to leave it on. But as if to compromise his urge to delete the sentimental version, they perform a faster, much less effective rendition, a full rocking run through which could have fit snugly on the Rolling Thunder tour only a year or so later. Opening side two, it's an interesting decision to include two varying versions of one song, and it works; the harmonious, almost religious ballad closing side one; the raggedy, harmonica dominated hoedown take beginning the album's second chapter.

Dirge is an all out classic now, a legendary instalment in the bitter Dylan-Sara saga. "You were just a painted face on suicide road" is perhaps one of the most vicious lines Dylan ever wrote, yet on the tape of the recording it's subtitled "For Martha," as if to disguise the truth behind the dark lyric. Musically, it's skeletal but effective, with thudding, simplistic piano notes and Robertson acoustic soloing. It

works devastatingly, and one wishes there could have been more Dylan-Robertson duals in this manner. Robbie does remarkably well too trying to keep up with Dylan's frenetic pace and timing. A disjointed, twisted and emotional exposed glimpse into disdain, regret and resentment. Fraboni later said, "Bob went out and played the piano while we were mixing the album. All of a sudden, he came in and said, 'I'd like to try Dirge' on the piano.' We put up a tape and he said to Robbie, 'Maybe you could play guitar on this.' They did it once, Bob playing piano and singing, and Robbie playing acoustic guitar. The second time was the take."

The complete opposite to the dreary depths of Dirge is You Angel You, which is either a very early precursor to Bob's religious phase or a way to make up for the put downs and regrets of the track preceding it. Never Say Goodbye is more drunken sounding, with scratchy, untidy guitars battling with organ and piano flourishes. Bob's vocal seems heartfelt, full of love and admiration. There certainly are mixed signals going on here, and some critics would criticise this factor of Planet Waves. However, what they are forgetting is the fact that not all - or much in fact - of Bob's work is autobiographical. He assumes roles, plays them out and steps into the shoes of characters or imagined scenarios going on. Besides, even if Bob's work was all strictly from his own viewpoint and mindset, we all know that there is never one set mode in life, and nothing is black and white. If anything, the roller coaster of emotions and feelings juxtaposing against one another from track to track, only makes the album more human and relatable. Dylan reflects ourselves right back at us, leaving gaps, however unconsciously, for the curious listener to insert their own traumas and issues into the narrative.

Album closer Wedding Song begins with that unmistakable Dylan acoustic strum, with the plectrum beautifully clicking on the strings. Here Bob is singing a straight love song, or so it seems, depicting a rather idyllic life of completeness, saying goodbye to loneliness and hollow faces in the street. But there is a strain in the voice that cannot be ignored. Though a love song of utter devotion, he sounds strangled, strained, singing of a love that cuts like a knife. A few minutes in, he sounds more like a man under a voodoo spell, handing over everything in favour of this union. A forgotten, or at least overlooked twisted love song, not pure enough to be genuinely moving, and not venomous enough to be ironic. This is a man under some kind of spell, hypnosis, where all is inconsequential and meaningless in comparison to the love. The song is not beautiful, it's jagged like broken glass, his vocal cutting and the harmonica solos somewhat fiendishly desperate. Is this really the story of a man in love? Coupled with Dirge, these were the last two tracks cut for the record. There is something quite telling there. Much of the rest of the set is bright, and sentimental, but these two songs are deformed mutations of love, melted in front of the fire, still resembling their original forms but moulded out of shape completely.

On BobDylan.Org, writer Tony Attwood penned an interesting piece on Wedding Song. "I suggest, having written Dirge, he needed to write Wedding Song, just for a sense of artistic balance and his own well-being. And just to prove that he could still write songs like this. I don't feel that Dylan was writing about himself or his own experience here, any more than he was in Dirge, any more than most novelists cast themselves as the central character in each novel, any more than an actor plays himself every time he gets on stage. If there

is anything personal here (and as I say, I doubt it) it is to be found in the tremendous sense of power and liberation that comes from his saying goodby to the 'haunted rooms and faces in the street, To the courtyard of the jester which is hidden from the sun' – to the self torment..."

So there *are* others who don't believe every Dylan line should be taken as the gospel truth or a tormented confession from the song writer! Good to know.

Planet Waves didn't exactly get a boat load of acclaim. Rolling Stone summed up the feeling of disappointment felt by many others in their later review for Blood on the Tracks, writing, "Dylan has often said that his goal in the studio is to catch the feeling and the way he does that best is by keeping things simple. The artist knows how he works best... But the shortcomings of the approach must be noted. Dylan's electric albums have often been pointlessly sloppy, sometimes badly recorded and not nearly as good as some of the material warranted. To me, Planet Waves sounds like nothing so much as a rough draft of an unfinished work, a sketch of planned painting, something to be worked on, not released."

In Dylan world, the album is now kind of excluded from serious contention, often recalled in passing as his only record put out on Asylum Records. The World Tour which started around the time of its release also grabs most of the attention. Biographical myth and Dylan legend have seen it buried in the build up towards the disintegration of his marriage and the unleashing of Blood on the Tracks. But music should be enjoyed for what it is, and this is a fine record, played with tasteful passion by one of the greatest backing groups in history. It also helps of course that every song is a gem.

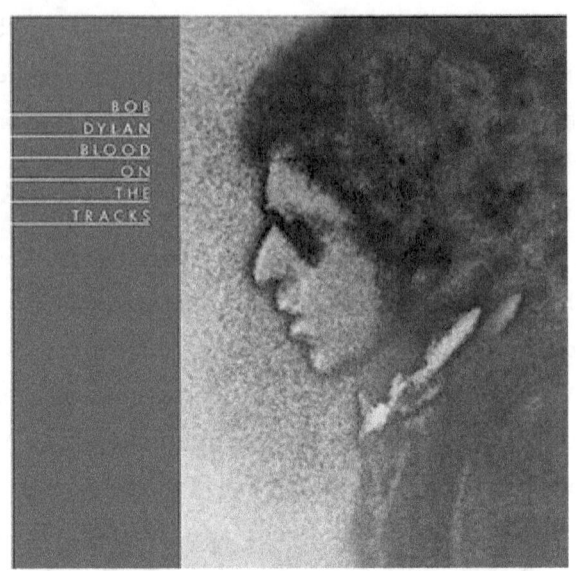

BLOOD ON THE TRACKS
The ultimate break-up album

"Of thee I sing, best album ever made, or that's my hypothesis, best rock &roll record ever — more heroic than The Sun Sessions, more consistent than Exile on Main Street, more serious than Never Mind the Bollocks, better than Revolver because there's no Good Day Sunshine on it, more discerning in its rage than Nevermind, more accepting than What's Going On, less desperate than Pet Sounds, and more adult than Blonde on Blonde and Highway 61 Revisited."
- Novelist Rick Moody on Blood on the Tracks

In 2012, Rolling Stone Magazine ran a reader's poll to find the greatest album of all time. Blood on the Tracks came in it a healthy number one. Out of all the thousands upon thousands of albums

worthy of such a title - the finest record ever made, no less - what is it about Blood on the Tracks which hits the spot for so many people all over the world? I believe it's to do with the raw quality it possesses, the sharp, stabbing, aching longing within. It's a break up album, at once sad and venomous, regretful and void of sorrow. We can all relate to the pulling sensation of a relationship crumbling before our eyes, as one half of us desperately clings on to the embers, and the other half is already packing the suitcases.

In his book, Bob Dylan Performing Artist: 1974 - 1986, Paul Williams suggests that Blood on the Tracks is the one Dylan album that could be picked out as a singular masterpiece. "Many of his albums are masterful, momentous achievements," he writes, "and what they achieve is exactly what the word momentous implies. If any of Dylan's records deserves to be singled out as a masterpiece, it is the one that most successfully combines conscious, deliberate creation (composition) with spontaneous expression (performance) - 1974's Blood on the Tracks."

Williams makes a brilliant point. Dylan has often expressed dissatisfaction with some of his recorded albums, stating that he loses something when entering the studio. Yet still, for the listener if not the creator himself, Dylan's albums still harbour that sense of urgency, the feeling that you are listening to a one-shot moment in time. You can almost see Dylan hovering around the mike, engineers on stand by at all times, the band waiting for their next psychic instruction. Bob has always been at his best when capturing the unexplainable spark of one point in time - be it merely 3, 4, 5 or 10 minutes - and Blood on the Tracks has this quality about it too. He sounds in pain at times, and the band, keeping things simple, back

him up solidly. They're strictly back up men, adding what is needed for the good of the song and letting Bob breathe and feel the mood.

The so called mood was a direct result of Dylan's actions, at least in some fashion. After the huge world tour had ended, Dylan was deflated and going behind his wife Sara's back with a Columbia Records staff member, Ellen Bernstein (musician Buddy Cage described it to me thus: "he was jumping her"). Dylan hadn't really had a sizeable critical smash since 1966's Blonde On Blonde, and after the crash seemed to have forgotten how to conjure up that naturalistic feral Dylan magic. Taking art classes in New York in 74 with Norman Raeben, Dylan had some kind of awakening.

On the Dylan Who's Who website, the importance of Raeben on Bob is made very clear. "Norman Raeben was one of the most influential people in Bob Dylan's life," it says. "It was Norman Raeben, Dylan said, who, in the mid '70s, renewed his ability to compose songs. Dylan also suggested that Norman's teaching and influence so altered his outlook upon life that Sara, his wife, could no longer understand him, and this was a contributory factor in the breakdown of the Dylans' marriage."

Dylan himself explained that Raeben "taught me how to see in a way that allowed me to do consciously what I unconsciously felt... When I started doing it, the first album I made was Blood on the Tracks. Everybody agrees that was pretty different, and what's different about it is there's a code in the lyrics, and also there's no sense of time."

Importantly, Dylan found, through painting and expressive freedom, how to channel that Bob of old, a songwriting force of nature who had literally redefined the craft and changed the world in

the process. Consider the genius of Highway 61 Revisited and Blonde On Blonde and you wonder, without much luck, just where did this stuff come from? When Dylan became a family man in Woodstock, he left behind the counterculture and the Bob Dylan of old. He even looked like a different man, he had physically changed and was slightly afraid of the obsessive Dylan fandom and worship that had been taking over his life. Had he not had the crash and slowed down, Dylan sincerely believed that he'd have died.

Even though the records he made in the wake of the crash aren't earth shattering to most listeners, and indeed lack the legendary Dylan trademarks, they are classic albums all the same. Each one has its own charm, capturing the Dylan of that time sublimely. Take a look through 67 to 74 and you see a development that is quite remarkable. To understand why Blood on the Tracks caused such a reaction, consider the records that preceded it. The bare boned, raw edge that John Wesley Harding (1967) possessed was in total contrast to the colourful and eccentric work Bob released only 18 months earlier. The very same year he also recorded his legendary private Basement Tapes with The Hawks, soon to be The Band, in various New York locations. It's those tapes in fact that form the vast bridge of harsh difference between Blonde on Blonde and John Wesley Harding. Had his hungry public heard the results of the recordings with The Hawks, John Wesley Harding record might not have seemed so surprising to them.

Nashville Skyline though was the one that really divided folk. More conventional though it may be, Nashville Skyline is easy listening at its very best - if you really want to call it that. It's Dylan doing country, and he does it as good as the old pros. Of course, having

Nashville legends like Charlie McCoy on hand to help was only going to guarantee its success, but Dylan's new vocal style was also an important element to the album's quality. The nasal whine was all but gone, making way for a softer, smoother Dylan vocal which fit with the music. Although this style would vanish again by 70 and the classic Bob Dylan tones would return, the short interlude is a treasured era, for me at least. "What Dylan did for the Nashville recording scene at least," Charlie McCoy told me, "opening it up to a brand new huge group of artists, was amazing. The Nashville based artists are so personable, that Dylan seemed like a recluse in his non-communicado approach to dealing with studio musicians."

When Dylan returned in 1970, it was with the despised Self Portrait. People thought Dylan had gone too far into himself, disappearing up his own backside as many a rich and satisfied artist had done before him. The supposedly self satisfied Bob Dylan of the early 1970s returned after the critical butchering of Self Portrait with a collection of new songs on the New Morning LP. Released only four months after Self Portrait, the Dylan of old had returned and the songs were stronger than they had been since the mid sixties. What also returned was the classic Bob Dylan voice, that iconic nasally drawl, a familiar and comforting voice to say the least.

In the summer of 74, Dylan stayed at his farm in Minnesota and began writing what he called some "personal songs", 17 of them in fact. His first thoughts were to record the record with a full electric set up, When he ran through the tracks with musician Mike Bloomfield, the rehearsal came to nothing. Bloomfield had of course been an important factor in the mid sixties whirlwind era, but he couldn't figure these new numbers out at all. "He came over and

there was a whole lot of secrecy involved, there couldn't be anybody in the house," Bloomfield said, painting the portrait of a strange day indeed. "He took out his guitar, tuned to open D tuning and he started playing the songs nonstop. He just did one after another and I got lost. They all began to sound the same to me, they were all in the same key, they were all long. I don't know. It was one of the strangest experiences of my life. And it really hurt me."

Actual recording eventually started at A and R Studios, New York City, in September of 1974 with assorted musicians. The original intended group Deliverance were tossed aside after a mere two days, keeping behind a few members, like steel guitar player Buddy Cage.

"We had the same A&R as Bob," Buddy told me in 2015, "the girl that Bob jumped when he split from Sara. A&R was working bi-coastal at that time for Columbia. One of his tunes, You Angel You (from Planet Waves) was about her, the A&R woman. He wrote about references to Cleveland, where she was from. Anyway, she played some of our stuff for Bob. We were about to embark on an East coast tour, and Bob asked if I was interested in laying down some tracks. Snap! You bet! And our road manager and the A&R were great friends and they picked out appropriate times. Closed session. But I showed up with six other folk. When I pointed that closed deal, our two roadies said, 'You're not gonna set up your own steel?!' 'Of course.' Our huge chauffeur and body guard, Sal Vetrano added, 'You're sure as fuck not gonna show up to a Bob Dylan session in a fucking cab!' Right. Perish the thought. Now, there were five or six of us, including me. When we met in the studio lobby, Bob showed up slick in his customary black leather jacket and western boots. He was knocked over when he saw all of them, but each one introduced themselves

and charmed Bob. And Sal said 'I'm going out to the nearest wine store - some good shit.' But he said it was a little too early to drink. Mick Jagger was already there - drunk! This was Phil Ramone's studio: the great man was serving not as a producer, just the engineer. Holy shit! And Bob says to Mr Ramone, 'Phil, play the tape.' 'Uh, which one?' 'All of them,' Bob replied. 17 or 18 in the can. It was gonna be a long day."

Cage was stunned by the tracks. "They were gorgeous," he said with enthusiasm even 40 years on. "I was immediately intimidated. Where would I fit? And I wiped my forehead and said, 'Bob, the best thing I can do for you is to pack up my steel and leave this alone. As they are. It's a masterpiece!' He said 'Awww shucks' or something and said, 'well try some, I'd really like you to add some stuff.' Whew! So, what does Bob say? 'Phil... play 'em again.' All 17! Sweet Jesus! We started with Meet Me In The Morning. I looked through the glass in front of the control room, and this natty dresser sits down on the couch. Just as Phil starts rolling tape, I recognized the gent - God! It was John Hammond Sr. Oh, Christ. It was that one last take and Mr Hammond told me how he loved my playing on that song. Truly, a thrill for me."

Legendarily, Bob cut and mixed the record in a matter of days, but it was his brother David Zimmerman who told him the album was much too stark. Somehow, he persuaded Bob to go back in there and re-cut five of the songs, choosing musicians himself and sending them over. It was about making the record simpler, more understated, perhaps warmer. Sound 80 in Minneapolis was waiting for him.

Bassist Billy Peterson told me about meeting Dylan for the recordings. "The first time I met Bob was at Sound 80. I walked into

the recording studio and he was sitting there. His brother, David, had hired me for a lot of sessions before that. He didn't tell me Bob was in town. So when I walked in the studio and looked at Bob, I backed out of the door and said 'David what's going on?' and he said 'we're gonna re-record half of the record, he doesn't like half of it,' so I was thinking to myself, 'wow this is really gonna live!' And it did, so that was my first meeting with Dylan. He was very nice, very cordial. As far as recording with Dylan, he was very open to suggestions, on the contrary to his reputation in the studio that preceded him. So he was very open and we changed a lot of things and he respected a lot of us guys. He was real loose about input and wanted a lot of input from us. So everything we came up with was really taken very well by Bob for that session. Well what I personally thought was that it was something that he wanted to get cut, so I thought that if he hired me, he had hired me to do what I do best and that was just be myself in the studio, respond to his music and contribute to the highest level I could. I think that's what David expected too. He had worked with me before and knew I could do it. I didn't have any preconceived notions about Blonde on Blonde or his acoustic stuff. I mean, I'd heard it, of course, but I wasn't gonna go in and try and emulate that stuff. What you got was me, and that's what lived I guess."

I put it to Billy that there were some terrific musicians on that record. "Yeah that band was really a great band and not enough credit goes to David Zimmerman for producing that record. It all goes to Phil Ramone and he wasn't even on set in Minneapolis and Dylan's brother was really responsible for putting us all together. He knew what we could contribute and he had a really good mind of the big picture of what could possibly get done with that bunch of

different musicians. So I think that basically he had a nice picture of what he thought could happen and I think he was pleased with what we did."

"I remember I had to leave the session one night when we recorded If You See Her Say Hello," Billy continues, talking of specific memories of the record. "I was supposed to be on that, there's supposed to be bass on it but there's none on it. I had to split and go play a jazz club that night with a band called Natural Life. We were gonna get a record deal and had a steady gig. Bob said 'man I wish I could come down and hear you,' but he understood that I had to split. The end of the session I went to pick up some gear - this really sticks out in my mind - and David and Bob were out in the parking lot. It was like on a Sunday and it was just colder than heck. It was Minneapolis and it was the middle of the winter, right between Christmas and New Year in 74. I went to pick the gear I had left in the studio and they were in the lot having a cigarette. I remember Bob pulling down the window and yelling across and saying 'Hey man, I really appreciate what you've done on this record and I like your playing a lot. Thank you for your contribution.' That was pretty cool. He really loved Bill Berg (drummer on the album), and wanted to take him out on the road with him. He was ready to do animation for Walt Disney though. But that stuck out, that he really complimented me very highly on my playing. I'll never forget that. He was very cordial and very open. It was like a jazz attitude really. You hire great players to give you what they hear and that's what Bob and David did. They hired great players and it came together. It lived."

Greg Inhofer played keyboards on the five re-cuts, and I spoke to him at length about the sessions. "I was working in Kevin Odegard's band, one of the other guys on Blood on the Tracks. His manager just happened to be David Zimmerman, Bob's brother. They were using the studio rhythm section and needed keyboards so Kevin called. The first meeting was very nondescript. He had a cold and was a little standoffish. I guess my account differs from Chris Weber's (a guitarist on the album). Chris seems to remember himself being the musical director. He had brought a vintage guitar down for Bob to look at and if you ask Chris, he taught us all the songs. As I remember, he didn't teach me anything. Bob would start playing the changes and we would all start fumbling along until the edges were smooth. For Tangled Up In Blue Bob wrote the chords on the margin of a newspaper and ripped it off. "Here's the chords to the next song" he said as he threw it on the organ. Kevin then suggested we move the key up to A, so I wrote the new chords next to his. As far as freedom to add our own parts, they were all our own parts. Bob didn't tell us what to play, he would just start playing and we would join in. He would comment if he liked something a lot or if he didn't like something. On Your a Big Girl Now I played a 3rd in the bass over the last chord on the piano. Bob heard it and came over and said "Hey what's that?" I told him I just put the 3rd in the bass. He said "I like that. Keep that in." So Billy played it on bass also."

Greg, unaware that Bob Dylan was going to be there at all, must have been pretty stunned to say the least when the icon appeared before him. "I had no idea what I was coming in to play on. I hadn't been told it was Bob Dylan. It was shrouded in secrecy. It was a pretty normal session; musicians, coffee, questions like "hey what are you

playing there?" My biggest memory was the effect the sessions had on me. Like I said, he was pretty aloof. It was all business. We did a couple songs on the Friday and that was supposed to be it. Bob liked what we did so he called us back in on Monday. We did a total of 5 out of the 10 songs on the record. I can't really say that Bob got on with anyone. He did what he needed and said what he needed. He certainly was not rude or egotistical. He was a little introverted. I did see him at a Stray Cats show a few months later. He was checking them out to be an opening act for his next tour. I went up to him and said "Hey Bob, I'm Gregg Inhofer. I played on Blood On The Tracks." "Oh yeah" he said, looking back to the Stay Cats. That's the last time I saw him."

Kevin Odegard was also present at the recordings, playing guitar. "Gregg Inhofer and I were already playing gigs together by that time," he told me, "and continued to play together for decades afterward. He is a brilliant and imaginative keyboardist, the best I had ever played with, and remains so today. The other musicians were simply the best studio musicians we could find for the sessions. Idiot Wind was first. It didn't sound right at first; discordant, but it grew on us as Chris Weber worked with Bob on a more powerful arrangement. The other songs were phenomenal to witness live in the studio, one or two takes at most. Lily, Rosemary and the Jack of Hearts played like a motion picture to us, and was almost as long. Tangled Up In Blue was boring me in the key of G, so I suggested to Bob that we move it up to the key of A, where it took off like a rocketship with Bob reaching for the notes. One take and done. That was it, and I'll never forget the silence afterward as we stood around Bob after tumbling through the final three chords. It was an astounding

performance, breathtaking for everyone there, including, I believe, Bob, for whom the emotional content of this album became both a watermark and a millstone. He had a cold, and was thoroughly detached throughout except for a few elated moments he shared privately with Bill and Billy, both of whom he obviously admired."

Though the musicians had varying experiences of working with Bob, the results are superb from start to finish. Indeed, this is a perfect album if there ever was one. The sessions in Minneapolis captured a spellbinding Bob Dylan in full flow.

Tangled Up in Blue is the opener, one of Dylan's cleverest and most stirring songs, with its building block chord structure and lifting melodies. Dylan's vocals are wild, expressive and emotional, going up and down from one extreme to the next. It's an extremely well put together multi layered monologue, with well observed, simple backing that gives itself to the lyrics. The Telegraph later called it, "The most dazzling lyric ever written, an abstract narrative of relationships told in an amorphous blend of first and third person, rolling past, present and future together, spilling out in tripping cadences and audacious internal rhymes, ripe with sharply turned images and observations and filled with a painfully desperate longing."

Dazzling is a good word to describe the force that hits me whenever I play the song. Its immediate warmth - the cushioned safety of the acoustics and shuffling drums - always fools me into getting cosy within Dylan's literary stream, and leads me into a false sense of security. I know what is coming in the rest of the record, yet I fall under the spell of this marvellous opener every time. The optimistic melody and fast paced progression is hypnotic to the point of locking

you in place. The original recording done in New York was much less urgent, with a similar vibe to Shelter From the Storm in its chord structure. The released recording however has a real bounce to it that is endlessly infectious. I seem to find new things to like about it every time I put it on.

Things wind down considerably for the more sad and reflective Simple Twist of Fate, a song with warmth as well as regret. Dylan paints a vivid and beautiful portrait of what I perceive to a couple first experiencing love. The "twist" here comes in the fact that the man still feels alone, despite the blossoming flower of love before him. Are alarm bells going off in his head, as if a warning of what is to come? And is this really a song to his old flame Suze Rotolo? Some believe so, and I can perhaps see the reasons for Bob revisiting a young, innocent love affair from his younger days when going through a bitter, sad divorce in his mid thirties. One thinks of Dylan reflecting back, putting himself in his own shoes as a man in his early twenties, yet to meet Sara, yet to experience true heart ache. The song has an air of melancholy that is at once comforting and heartbreaking, and it's for this reason I believe Dylan nailed the conflicting emotions felt while in the midst of a dying love. He looks back to naive days, while his established family life slips away.

This sinking, low down feeling is even stronger on the next track, the perfect You're A Big Girl Now, with a Dylan letting go while clinging to the last embers of the affair. "I can change I swear" just hits the heart, as do Dylan's animal like cries, pleading for forgiveness and mercy. When Bob quotes the line "Love is so simple", we can't help but grasp the irony. Love, in Bob's world, is anything but simple. But the music backing him on this painful ballad is

definitely simple, effectively propping up one of Bob's most naked and vulnerable lyrics.

The daggers and clenched teeth are out for the vicious Idiot Wind, unarguably a song aimed at Sara. His rasping voice screeches, often misses the spot, landing between notes rather than on them, and tearing at them like a beast. The organ, drums and guitars in the mix are not strictly playing together as a tight unit, and often sound clumsy, falling over one another at various points. There's a sense of desperation to the music, lagging behind almost, as if the musicians are trying to keep up with the fiery, wound up rants that Bob spews from his mouth. One can picture them, open mouthed, gawping at this revelatory outburst. Like a Van Gogh painting, it's not aesthetically perfect (who would want it to be?), but it captures an essence that a neatly produced love ballad simply could not. It's raw, naked and ugly, but by god is it addictive listening. If Dylan was troubled that audiences could get so much pleasure from a sad album like Blood on the Tracks, he was obviously too close to the subject matter to grasp how powerful this really was.

The original Idiot Wind was a stripped acoustic recording, radically different to the explosive Minneapolis version. Here, the claws are sharp and flying everywhere. But Dylan has claimed it was a song he took on with a painter's sensibility, which is believable, seeing as Dylan was really getting to grips of himself as a visual artist around this time.

"That was a song I wanted to make as a painting," Dylan said of the song. "A lot of people thought that song, that album Blood on the Tracks, pertained to me. Because it seemed to at the time. It didn't pertain to me. It was just a concept of putting in images that defy

time – yesterday, today, and tomorrow. I wanted to make them all connect in some kind of strange way. I've read that that album had to do with my divorce. Well, I didn't get divorced till four years after that."

The thing about Blood on the Tracks is that no matter how much a Dylan admirer can enjoy it every single time you put it on, it doesn't take away the fact that we know this is Dylan singing about his drawn out marriage break up, even if he won't admit it himself. In his book Chronicles, Dylan even says it's all based on the work of Chekhov, and suggested that whoever pointed it out as autobiographical was hopelessly misguided.

In an interview with Cameron Crowe ten years later, Bob said, "I read that this was supposed to be about my wife. I wish somebody would ask me first before they go ahead and print stuff like that. I mean, it couldn't be about anybody else but my wife, right? Stupid and misleading jerks these interpreters sometimes are... I don't write confessional songs."

"I thought I might have gone a little bit too far with Idiot Wind," Dylan told Bill Flanagan, still denying it was about him and Sara. "I didn't really think I was giving away too much; I thought that it seemed so personal that people would think it was about so-and-so who was close to me. It wasn't... I didn't feel that one was too personal, but I felt it seemed too personal. Which might be the same thing, I don't know. But I'm not going to make an album and lean on a marriage relationship. There's no way I would do that, any more than I would write an album about some lawyers' battles that I had. There are certain subjects that don't interest me to exploit. And I wouldn't really exploit a relationship with somebody."

Bob's son Jakob famously said that Blood on the Tracks is basically just like listening to his parents having it out with each other. Whichever way you look at it, it's a strong album, with every song a killer. And for all the darkness, there is pure beauty in You're Gonna Mke Me Lonesome When You Go, an uplifting quality that brings to mind 63 Dylan. Though people have put this out there as a personal song (some say it's about Bernstein, some say Sara), but I go with Dylan's claims of it being mostly literary inspired. It's a brief snap shot, and not as tearing as songs like Idiot Wind. I feel Dylan isn't totally "in" the moment as he is on the blacker numbers. He sounds like a narrator rather than a character in the depths of his ordeal.

Side two gets off to a groovy start with the laid back vibe of Meet Me in the Morning, another fine song that Dylan effortlessly brings to life. The musical arrangement is sublime, bringing to mind some of the outtakes from the 1970 New Morning sessions. There's a nice blocky bass line, sweet guitars dancing together and a solid Bob vocal performance. A lesser known cut, but one that musically always pleases the ear.

It's become something of a cliché to call Dylan a story telling songwriter, but the next track, Lily, Rosemary and the Jack of Hearts, really is a story song. As if to prove its cinematic scope, two screenwriters even penned film treatments for the song, though neither came to fruition. Which is probably a good thing, as the imagery conjured up by the song itself is both a credit to our collective imaginations and Dylan's wonderfully descriptive lyrics, conjuring pictures and scenes with ease. Dylan sings of The Jack of Hearts, a leader of a gang with his eye on the town bank. We also meet Rosemary, the wife of Big Jim, and Lily, the dancer and mistress

of Jim. Jim is taken out in the end, the evil giant finally falling, though we don't learn who exactly performed the murder. Dylan leaves that open for the listener.

Dylan experts and scholars will inevitably speak of metaphorical subtext and allegories, but I see the song as purely a yarn, a story Dylan weaves at a blistering pace, keeping our interest up throughout. Like Isis, another wonderful story song on his following album Desire, there maybe are subtexts beneath the surface to be pulled out. But personally, I just want to know what happens in the end, and in the mean time enjoy the rich musical flavours and Dylan's marvellous language which not only keeps your attention, but merely sounds good too. Like in his surreal book Tarantula, Dylan plays with language with endless imagination here.

If You See Her, Say Hello is like holy gospel, its beautiful ringing organ like a sea for Dylan's voice to float upon. The dual acoustic guitars are crisp and clear, the percussion light in its fluttering. A gorgeous song, it has one of Dylan's sweetest vocal melodies and some of his most gentle words. Gone is the rage of Idiot Wind, the confusion of Simple Twist of Fate, replaced by an air of acceptance, of bidding the parted lover a pleasant farewell. Dylan, or the character, are standing aside, leaving a path for her to depart quietly, gentlemanly and with dignity. He won't stand in her way, but he hopes she might want to look him up again one day. Musically and melodically, this is one of his most touching and beautiful moments.

With just bass and acoustic, Dylan takes us into Shelter From the Storm, one of his anthemic, iconic tunes. Again, it's genuine class, as Dylan guides us through another descriptive character song, In only three chords, with no chorus, and no shift in structure, Dylan holds

every bit of our focus, and no matter how many times I hear it, I still cling on to every word. Despite it being another surreal, guarded story song, perhaps one acting as a masked confession, you can pick and quote lines at random and they can mean a hundred things to a hundred different people. Dylan's songs are personal, yet not personal enough to be closed to the listener. They are open books, and there for all to share, interpret and pull meaning from. Just don't expect Bob to tell you if your interpretation was right. If it's right to you, that's all that matters.

Buckets of Rain is a perfect end to the record, a neat, tidy and pleasing epilogue for both the album and the love which has been fading as the LP has progressed. When Dylan says that everything about her is bringing him misery, we can't help but relate to past relationships of our own. Again, all Dylan needs is a simple accompaniment and he hits the spot devastatingly. With its light melody and mood, the song is deceptive, in that it hides the bitterness of dead love behind its plain beauty. If Dylan claimed to be merely telling stories here, acting out mini films if you like, then he's a damn good actor for sure.

Blood on the Tracks is, and I am definitely not alone in saying this, a perfect album. Ten tracks, five a side, not a single wasted word, every line of importance, every note and chord impactful. It's one of the few records you can listen to from start to finish over and over and never ever get remotely weary of. Unusually, for such a pain filled album, it was a huge seller, getting to the top of both the American and Canadian charts, and charting highly everywhere it was released. As the years went by, it gained the reputation of being among Dylan's finest records, up there with the mighty Blonde on

Blonde and Highway 61 Revisited. For Blood on the Tracks to be mentioned in the same breath as these records was quite remarkable, rather like a mid seventies Lennon record being ranked as highly as Revolver. Given the fact that Dylan had largely been written off only a year or two earlier, forever judged against his classic records, makes the success and critical acclaim of Blood on the Tracks even more impressive. Now, it's possibly ranked as his greatest achievement. Dylan has rarely expressed satisfaction for any of his records, but given the fact he often picks these songs out for live concerts, even to this day, tells you he must rate the work.

"It sold more than any other studio album; still does," Kevin Odegard told me of the record. "This was the masterpiece he had visualized a few years earlier. He followed up very strong with Desire, also heartfelt, but alas neither work saved his marriage. Blood On The Tracks is not my favourite Dylan album. I prefer the wild mercury sound of Blonde on Blonde. This record connects on a visceral, raw emotional level from the first notes, and doesn't let up throughout. Emotion is the glue that holds it together, not craft or technique. In my opinion Blood On The Tracks is a modern classic; the greatest 'breakup' album of all time, like so many critics and fans are fond of saying. And it's true from a sales aspect as well. For me it's a bittersweet keepsake. The micro-notoriety I experienced as a result of the record has been a mixed blessing. I moved on with my career immediately thereafter."

Billy Peterson also reflected upon his work on the album, telling me, "Looking back on that 40 years ago. Well, you know, I really didn't think any of that stuff would live after that recording session on that day and especially the stuff we recorded in Minneapolis, but

the synergy of everybody - it all came together. The unbelievable two track that Paul Martinson did, Dylan just fell in love with them. Paul Martinson - a great engineer, I worked on thousands of sessions with him in the old days. Dylan just loved him. He made magic on the fly like great engineers did in the old days. Those are mixed right to two track, on the fly and those are the ones that lived. When Dylan went back and tried to mix the stuff, he liked Paul's stuff better. I guess looking back on it, history decided it was what it is today and I didn't really... I mean it was one of a thousand recording sessions I did, so I really didn't pay it much attention until it paid attention to me. You know, the funny thing about the credits being wrong on the sleeve is because half a million record jackets had already been printed in advance with the wrong names on the session. Nobody thought that stuff would live and when it did, the credits on the record have been wrong for 40 years and they've never got them right. So... And now it's bigger than ever, because it's like 'who's that mystery band on that album?' The internet's blown it up all over the place, like who we are and I think we got more attention because we were a mystery band than we would have if our names had been on the record. It's hysterical. We got the two Grammys, one back in 75 and one just last year for Hall of Fame, so I don't know. I think we let history decide if they like our performances or not. That's all you can really do. There's been thousands since then, so that's what I'm here to do. But history decided that one was good, so... There you have it my friend."

The musicians I spoke to remain uncredited on the sleeve for their work, but thanks to the internet, they can finally be proud of accompanying Dylan on what many see as his definitive album. But the brilliance of Blood on the Tracks is not so easy to define. There is

something here, an unobtainable otherness, an atmosphere that that could not be controlled or geared in anyway. Chemistry between musicians is very important and had Dylan not got together with this varied bunch of session men, thanks to his brother, Blood on the Tracks might not have achieved the level of brilliance it reached. Or, perhaps more fittingly, it would have wound up a very different album. Dylan's voice here, although typically Dylan, also sounds a little different. There's a heaviness to it that could not have been faked or acted, a realness, as if he's living the songs out on tape, despite the fact he insists they were character songs. But fiction or not, they sound confessional, lived, bitter, cynical, hurt, angry, vulnerable, pitiful, strong, defiant, sad; all at once, it must be added. And there, for me at least, is the secret. Blood on the Tracks is not only one of his strongest set of songs, it's also his most human record, where he's captured his own mood and got it down on tape. Sure, Blonde on Blonde was a monumental record, four sides of solid gold from start to finish. But the record is so instantly recognisable as iconic mid sixties Dylan, that it doesn't need or perhaps require as much direct emotional contact as Blood on the Tracks does. It's an exuberant, wild and at times humorous album, surreal and playful, and one of the finest records of its period. Blood on the Tracks however is something different. It's enjoyable yes, but you often feel guilty and rather perverse for enjoying it. It has a focus but is also so instinctive that it transcends structure quite quickly. With its direct simplicity, it somehow manages to make a connection directly to the heart and soul of the listener. It's undoubtedly because most of us (the lucky ones) know where Dylan, and indeed the characters in the songs, have arrived, and we've felt this way too. For all his enigmatic

behaviour, his poetic word play and god like reputation, on Blood on the Tracks he stripped his own enigma bare and showed us, quite plainly, that he too was human. It made Dylan more of an approachable, rounded artist, going beyond mere iconography and sitting down beside you, sharing his stories and feelings. It was released in the middle of the sensitive singer-songwriter boom of the mid seventies, but stuck out from the rest for one reason alone. Whereas a lot of those records were contrived attempts at reaching out to the more emotional quarters of the record buying public, Dylan didn't try and make his masterpiece even remotely pretty to shift units. His was an outpouring, an expressive cry, and he didn't care one jot if some bits were out of key or muddled. That only made the whole thing more real. The genuine truth of Blood on the Tracks, an album lacking in meaningless musical frills, is what's made the record last for forty odd years, while other lesser, perhaps more commercial albums have been buried in time. There's a lesson here. True art lasts, while mere product rusts away.

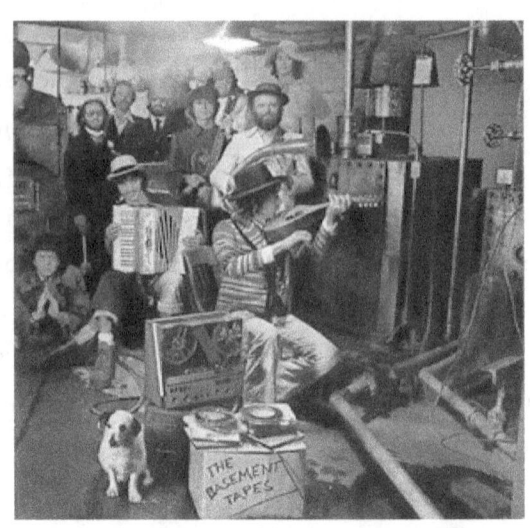

THE UNEARTHING OF
THE BASEMENT TAPES

The eventual release of the legendary Basement Tapes was a landmark moment in not only Dylan's career, but in the whole rock field. After all, these scratchy demos, recorded in various Woodstock domiciles in the 1967, had proved to be massively influential over the previous eight years. Heavily bootlegged as The Great White Wonder, you weren't cool unless you had heard them. These were hidden gems, classics left to crumble on hissy old tapes. If Dylan was recording all this in 67, the same year he released John Wesley Harding, then that year is undoubtedly the most prolific and busy of his career; even if most of the material didn't see release until 75, then later on the 2013 Bootleg Series entry.

In the late 1960s, The Basement Tapes were almost like the bible to scenesters and rock aficionados. Producer Joe Boyd once said that you could hear all those songs coming from bedroom windows all over the place. People would get together to spin these mysterious demos that sounded like they had been recorded fifty years ago. Everyone in the rock inner circle dug these recordings, while groups like Manfred Mann and Julie Driscoll even scored hits with some of the songs, namely The Mighty Quinn and This Wheel's On Fire. If Dylan really did write and record these for kicks alone, bored of releasing his own work on the tiresome rock and roll treadmill, it sure sounds as if him and The Band were having a good time doing so. As if to prove that he didn't old these recordings in high regard as finished, polished product, Robbie Robertson once claimed that Bob suggested they even erase their versions of the songs so no one would ever hear them. Thankfully, Robertson was able to dissuade him.

An interesting piece published in Rolling Stone in 1968, entitled Dylan's Basement Tapes Should Be Released, has Jann Wenner waxing lyrical of the rough and ready recordings. "The group backing Dylan on this tape is called the Crackers. Formerly they were the Hawks," he wrote. "The band, which lives with Dylan at his home, consists of Levon Helm on drums, Rick Danko on bass and Robbie Robertson on guitar. They accompanied him at Carnegie Hall for the recent Woody Guthrie Memorial program. Robbie Robertson has been working with Dylan for the past three years. The instrumentation is closest to Blonde on Blonde, including an organ, an electric bass, drums and two guitars, acoustic and electric. The singing is more closely related to John Wesley Harding, however. The style is typically Dylan: humorous, rock-and-rolly with

repetitious patterns. One of the things peculiar to this tape is that Dylan is working *with* a group; there is more interaction between him and the instrumentalists than can be seen in any of his other

efforts, plus there is vocal backup in the choruses from his band. The quality of the recording is fairly poor, it was a one-track, one-take job with all the instruments recorded together. The highs and lows are missing, but Dylan's voice is clear and beautiful. Additionally the tape has probably gone through several dozen dubs, each one losing a little more quality. Even though he used one of the finest rock and roll bands ever assembled on the Highway 61 album, here he works *with* his own band, for the first time. Dylan brings that instinctual feel for rock and roll to his voice for the first time. If this were ever to be released, it would be a classic."

Wenner makes a very interesting point about Dylan playing with the band, rather than just in top of one as he did on Highway 61 Revisited and Bringing It All Back Home. Though Wenner's article is ancient now, revealing hints of a then unreleased treasure which has now been available for over forty years, it's still a valid piece. Anyone

who recorded with Bob on those '65 records, and indeed on the likes of Blonde on Blonde too, can agree that Bob wasn't one for instructions. He'd pick up his guitar and start a song, and the others would just have to keep up. As interesting as the sounds on the three 65/66 albums are, it is clear they are largely session men backing up an enigmatic magician, keeping up with an erratic artist who knows no secrets of his own abilities. On The Basement Tapes however, there is a unity, a beautiful synchronicity in fact. Dylan is not simply being backed up by a rock group, he is a member of the said rock group. He's among friends here, relaxed, humorous and not hung up on having to be "Bob Dylan" the character and icon. There is little pressure, if any at all, and the guys seem to be having a lot of fun with the songs, some of them brilliant, others just daft and enjoyable.

In 2014, during the release of the Bootleg Series Basement Tapes, Bob spoke about the recording sessions all those years ago, answering a lot of speculation in the process:

"Oh... y'know, beside this, kind of was gonna stay up in Woodstock for a while, so... my band from the touring we had done together, those guys just came on up there, they liked it, too. And Robbie called me up one day and said, 'What's happenin'?' you know, 'What's happenin'?' and I said, 'Nuthin'.' He said, well he was in the mood for some nuthin' too. And it had a basement, typical basement full of pipes and a concrete floor, washer, dryer... We'd just kind of sit around and call out the songs and before we went down into the basement to put it on tape. Woodstock was a place were you could kinda go and get your thoughts together. It was an artist colony. There were plenty of painters who lived in that area, but very few musicians, who... we certainly knew of nobody up there playing

any music. Later there were, but when we were up there, middle of the '60s, we were pretty much by ourselves. The events of the day, they were just happening, they seemed to be a million miles away. We weren't really participating in any of that stuff, well it was the Summer of Love, but... we weren't there, so we did our thing where we wrote Million Dollar Bash, you know, go along with the Summer of Love. We had nothing else to do, so I started writing a bunch of songs. I'd write them in longhand and I'd write 'em on the typewriter and whatever was handy. Pencil, pen, typewriter... How do we go about writing our songs? I'd know I wasn't gonna write anything about myself, I didn't have nothin' to say about myself that I'd figure anybody else would be interested in anyway. You kind of look for ideas on TV or somethin' and just any ol' thing would create the beginning to a song: names out of phone books and things. I don't know when I became aware of these songs being bootlegged. I won't know how to get that record, I guess they were selling them in record stores. It's always interesting when someone takes a song of yours and re-records it. But these songs weren't tailor-made for anybody. I just wrote what I felt like writing."

When Dylan finally gave Columbia the permission to release the set in 1975, his vast fan base whooped and hollered in delight. Sure, they had heard most of the songs on crackly acetates and shoddy bootlegs, but now it was coming out officially as a *proper* album. This was the music that had influenced a whole new breed of rockers; and not only that, but even leading The Beatles towards simpler recording techniques for Let it Be. Recorded in the heat of psychedlia, by then coming to its end as a proper movement and transforming into a bloated parody of itself, it's a cliché to say it was an antidote

against the shallow pop and rock trends of the day. We are supposed to say that these recordings, and of course the rustic simplicity of John Wesley Harding, made Sgt. Pepper - an album Dylan had no time for - look self indulgent and ridiculous. The truth is, without putting things into a tidy order to make writing about this period a lot easier, Sgt. Pepper is a magnificent album that exists in its own little universe entirely. The Beatles weren't a part of a movement, they had their own movement, and the others followed them. Dylan had his own scene too, not better or worse, but different. After 65, neither were really influencing the other. The Beatles were in their bubble, expressing themselves in the studio now the live work as over. Dylan was going somewhere totally different, back to the old weird roots of Americana. There was room for both types of music - the sparse splendours of The Basement Tapes and the far out, complex arrangements of the psychedelic rock scene.

The fact that The Basement Tapes eventually hit the shelves in 1975 is actually rather interesting. After all, consider that Dylan had just put out his new masterpiece, Blood on the Tracks, the record that reminded the world of his song writing prowess and his ability to capture the beauty of the moment and get it down on tape. Blood on the Tracks, in many people's opinion, is perhaps Bob's most perfect LP, a solid onslaught that never lets up. It floors you every time you listen to it. Like Blonde on Blonde, it is united in its vision, the lyrics are intricate and endlessly imaginative, while the music is tasteful and neatly played. Had Bob put out The Basement Tapes in, say, 1972 or 73, the critics would have continued on with their brutal Dylan kicking and insisted he was virtually over as a relevant figure; little more than a relic from another time, who hadn't matched his mid

sixties work, or even come close to it. The Basement Tapes emerging among this anti Dylan era would have been proof of this, no doubt. The writers and doubters would have pointed out that even Dylan's abandoned demos and half finished, scrappy frolicking throwaway ditties were better than anything he could come up with in the early 1970s. Perhaps this helps explain why Dylan finally accepted the idea to release the tapes. He had proven he still had it, that he was not a dinosaur of the past living on his past achievements. He was a vital artist again, just as important as he had been in 1965 and 66. Agreeing to release these crusty tapes was seen more as an act of cool than an act of commercialist desperation, which it definitely could have been construed as had he not made Blood on the Tracks.

The 75 release, consisting of 24 songs over four sides of vinyl, is very enjoyable indeed. With a few overdubs and slight cleaning up of the sound, it's rough and shaggy charm from start to finish. The energy of Odds and Ends, opening the set, brings to mind vintage 65 Dylan; fiery, electric, jagged and speed rapping. The version of Million Dollar Bash is good, but the one put out on the Bootleg Series is vastly superior, really coming to life even if the quality of the sound is much crustier. There's a care free frivolity to some of the songs, but others carry a genuine weight, with Dylan's voice beautiful, sorrowful, light and soulful. Goin' to Acapulco is utterly marvellous, with one of his finest vocal performances of all time.

Songs like Too Much of Nothing really cook too, with a nice groove and laid back vibe about it. The version of You Ain't Goin' Nowhere is good too, soon to be covered excellently by The Byrds. The version that appeared on Dylan's second Greatest Hits is the best for me, though this one is notable as well. The one definitive classic on the 75

release - that even non Dylan fans familiar with The Basement Tapes will enjoy - is the truly haunting and spectral This Wheels On Fire. Rocked up and made infinitely more trippy by Julie Driscoll and Brian Auger, Dylan and The Band take it through the swamp, a truly moody rendition that closes off the double set wonderfully.

The choice of tracks is hardly perfect, and anyone interested in feeling the free vibe of these sessions has to purchase the Bootleg Series version, released nearly forty years later. As great as the 75 addition is, it's also lacking the Basement magic. The fact that solo Band tracks were included seemed to be an odd choice too. Obviously Dylan didn't have a problem with it, as some listeners indeed did, as the release went ahead with Dylanless tracks. The fact that The Mighty Quinn and other already legendary songs weren't given an airing was also criticised. The truth is though, that the 75 set was greeted like an unearthed religious text, and only today, when compared to the new enhanced version, does it seem slightly underwhelming.

On the whole, The Basement Tapes are immensely enjoyable, and they are entirely unique in Dylan's discography. They are songs recorded for the fun of it, with him and The Band just hanging out together, recording music which Dylan intended on keeping secret for as long as possible. In those relaxed sessions he would explore many ways of writing and arranging a song, some of which would come into use in his 1970s recordings. Released in 1975 at the height of his powers, Dylan took a rare look back at his own past. It was a brief glance mind you, and in no time at all he was back in the studio cutting a new record.

DESIRE

Inspired brilliance with Jacques Levy

Following up the raw, painful intensity of Blood on the Tracks was never going to be easy. But the "task" of following up was made easier somewhat, due to the fact that Dylan couldn't care less about following up a well received, successful album in the slightest. In fact, if an album in a certain style has been successful, Dylan will often veer in the complete opposite direction, for whatever reasons we are not sure of. Blood on the Tracks was his bitter split album, an album so real and cynical and twisted that every love damaged loner adopted it as their anthem. Lovers of the trodden, damaged Blood on the Tracks might have been surprised by his follow up. The next album, the exotic and exuberant Desire, could not have been more different; like a peacock to a battered old crow. It's musically richer, lyrically more flamboyant and there is an air of mystery, magic and

vitality to the whole thing. There are of course a number of reasons this album differs so greatly from Blood on the Tracks, some plainly literal, others not so.

The lyrics were a collaboration with Broadway writer Jacques Levy, whom Dylan had met around the place. He bumped into him again one day and came up with the idea of working on the words together. Levy lent the new material a cinematic edge, and whereas Dylan songs were often like mini films in abstract form before this, Levy's literary flare gave the project more focus, pace and narrative. These were character songs, fully rounded stories in their own right.

"First of all, it got me a little nervous," Jacques Levy later said. "I said to him — and it was very funny at the time, though I don't know how funny it will be now — I said: 'You know, I write the lyrics; I don't write the music.' It never dawned on me that he was going to ask me to write lyrics for him. I think he liked the idea that I could tell a story, that there was a story in that song," Levy adds. "Bob is not that good at telling stories. He's doesn't go from A to B to C to D to E. He's got a lot of good stuff in his songs, but they don't usually add up to a story."

Much of Desire and its recording came about spontaneously, as so often is Dylan's want. Driving down the road one day, Levy and Dylan spotted an exotic looking woman walking across the street holding a violin case. Something in Dylan told him he had to stop the car and invite the girl to jam. It was Scarlet Rivera, and she became the violinist for the album, and inevitably the subsequent Rolling Thunder Revue tour.

Scarlet herself recalled to me the magic and freedom of recording Desire with Bob throughout 1975: "When recording Desire, Bob gave

me an incredible amount of artistic freedom to create on the spot, giving me sparse suggestions during the super intense recording process. I know he was liking what was unfolding and probably didn't want to say something that would make me self sensor my ideas in a way that could have affected what I played or not. In the live shows our interaction was equally liberating as he allowed the songs to take new shape, tempo and feel that made them come to life differently than the studio version on Desire, such as Isis for example. I sometimes listen to Desire as well as Live 75 and other bootleg versions of songs I performed with Bob Dylan and hear the musical chemistry, and magic in the tracks."

Initial recording sessions had included an overcrowded assortment of star players, but there was no way in the world this was gong to work. The album's engineer, Don Meehan, recalled to me, "more musicians kept coming and I'd continue to go out and set up more microphones. Every rock star who was in town, including Eric Clapton, showed up to play on the session. Dave Mason and Jim Krueger on guitars, Mark Jordan on keyboard-organ, James Whiting Sugarblue on harmonica and Vivian Cherry, Hilda Harris and Joshie Armstead doing backing vocals. Erik Frandsen on slide guitar, Michael Lawrence on trumpet, John Sussewell on drums, Perry Lederman on guitar, Sheena Seidenberg on tambourine and congas, Mel Collins on tenor sax, Neil T. Hubbard on guitar, Alan Spenner on bass, Jody Linscott on percussion, Tony O'Malley on keyboards, James Mullen guitar and Paddie McHugh, Francis Collins and Dyan Birch vocals. They just kept coming and I just kept setting up microphones. I think I wound up with about thirty microphones and it seemed like that many musicians. Before it was over the entire

little studio was lined up with musicians, wall to wall, and I was even running out of tape tracks to put them on. It was almost like a hall of fame night, with a tribute to Bob Dylan. The difficulty was that with so many star players and everyone playing on top of each other and soloing and playing fills on one another, there was almost too much music to sift and sort and come up with any kind of decent mix. And I remember that the mix for Rita Mae (outtake from the sessions, later used as a b side) was just a total nightmare with so many musicians. At four a.m. we were still at it and my head felt like it did after the accident. The session finally broke at about 5:30 a.m. For me it was a twenty hour day. Luckily, De Vito called for a limo to take me home the sixty miles I had to go. I certainly couldn't have driven it. I was dead on my feet. My ears were ringing and my head was spinning. That initial session wiped me out for a week."

Upon Dylan's insistence, bassist Rob Stoner got the band down to a four piece; Bob, Scarlet, Stoner and drummer Howie Wyeth. There were other appearances, notably from Ronee Blakely who sang back up and the great Emmylou Harris who can be heard throughout the record. Adding to that the floating, almost ghostly sounds of Rivera's gypsy violin, and you have one of Bob's most colourful, varied and magical records,

"The drummer was someone I had been working with in my own band, Rockin' Rob and the Rebels," Stoner told me in 2015. "When Bob gave me the green light to hire Howie Wyeth for the dates, I knew the feel Howie and I had doing my material would translate well to Bob's. It (Desire) really is a timeless, unique piece of work on every level. I was very gratified to see that my plan for a smaller group with the personnel I specified was working out so efficiently."

Opening song Hurricane is an absolute blinder, and in my eyes one of the finest songs Dylan has ever written, or will ever write again. Telling the story of the wrongful imprisonment of boxer Rubin "Hurricane" Carter, Dylan takes a film/novel approach and gets us inside the twisted tale, the court case and the sickening injustice of this racist conviction. Bob howls his heart out and the band back him up relentlessly, charging defiantly like an army on horseback for the whole eight minutes plus of this spellbinding piece of music.

Don Meehan told me all about the recording of Hurricane and how it had to be re-cut down the line:

"Later in October, much to my surprise, I got called in to do Hurricane over again, and this time Bob would sing the duet with actress Ronee Blakely. Because there was too much leakage on the multi-tracks to make a vocal "punch in," we had to re-record the entire song. Dylan was rehearsing for his upcoming tour, and the musicians from the Rolling Thunder Revue were still available. We went back into the studio, and a new, faster version with Ronee providing a harmony vocal. There were no edits in the song that ran over eight minutes. I learned later that eyewitness Patricia ("Miss Patti Valentine" on the record) Valentine had filed a lawsuit that was dismissed by a federal district court and the United States Court of Appeals for the Eleventh Circuit affirmed the dismissal. Soon after Desire's release, Dylan and the Rolling Thunder Revue played a benefit concert for Carter in New York City's Madison Square Garden, raising $100,000. Even though there was a new trial, Carter and Artis were once again found guilty and Carter was sentenced to two consecutive life terms. But in 1985 Federal Judge H. Lee Sarokin of the United States District Court for the District of New Jersey,

ruled that Carter had not received a fair trial and set aside the conviction, commenting that the prosecution had been "based on racism rather than reason and concealment rather than disclosure." In 1988, after the prosecution said they would not seek a third trial and filed a motion to dismiss, a Superior Court judge dropped all charges against Carter. The song was published on the album Desire in January 1976, making the Carter case known to a broad public. The recording is credited with harvesting popular support for Carter's defence.

"A few weeks later, the night of December 7, 1975 to be exact," Meehan continues, "I got a frantic call from Don De Vito at the studio, that Yetnikoff just called him from downtown and said that I have to get up the Dylan tapes and erase everything we did on the first version of Hurricane. He said he'd tell me why later. But just do it he told me. I was quite upset over this extremely unusual request. But I knew I had to carry this through. There was a special cage within the basement vault area in our 49 East 52nd Street Studios that was under another lock and key that contained all of Bob Dylan's tapes, which had to have special permission to enter. After rousing my boss, Roy Friedman, at home and explaining the situation, I took the tapes to a mixing room and proceeded with the destruct order. I felt that this performance of Bob Dylan and Emmylou Harris would be gone forever. What could I do to preserve this somehow? Not much. But then I remembered that I had made a reference copy for myself that was at home. This was a practice I generally would follow when I wanted to analyze a mix. And so, I started with the razor blade, cutting up and trashing all the quarter inch mixes. Then, I put up the twenty-four track two inch tapes and played them. There I

was, all alone with an order and a decision like this that I knew must be followed, so I did the next best thing I could think of. I erased all of the vocal tracks of Bob and Emmylou and made reference on all of the paperwork, the job sheets, the track sheets and the reference cards, with my initials and "per Don DeVito, Walter Yetnikoff and Roy Friedman," with the date. I wouldn't find out the whole story about the why's and wherefores on this until twenty years later in a casual conversation with Don DeVito. There had been the legal problem with the lyrics of the song pertaining to certain names that Bob used."

It was certainly worth the hassle, for Hurricane really has stood the test of time. As great as Desire is, a couple of songs at least do sound a little aged today, though they are still fantastic. But Hurricane remains as vital and dynamic as ever, bursting from the speakers and grabbing you round the scruff of your neck, reminding you ever so beautifully of Dylan's prowess as a story songwriter, and how corrupt this world of ours can be. It's a straight forward retelling of the Carter story, with minimal metaphors and subliminal messaging, Every thing here is intended just as you hear it.

"He asked me very early on whether I had any interest in Hurricane Carter," Levy later said. "As it turns out, I knew all about Hurricane Carter. It was just a coincidence. Bob wanted to do something about it, felt he was an innocent man — and I agreed with him."

Hurricane is a magnificent song in its own right, but as an advert for an innocent man being roundly fucked by the justice system, it has no competition. This is a statement impossible to ignore, a "protest" song in the fullest sense, in that it wishes not only to point out an injustice, but longs to change it, to right the wrong and make a difference. With the song a Top 40 hit, people became aware of

Rubin's story, and the 1976 benefit show which raised 100,000 dollars for him broadened the consciousness even more. It took ten more years, but in the end all charges were dropped against Carter, and he became leader of Association in Defence of the Wrongly Convicted. A protest song really did help to change the world!

Isis is an alluring mystery, a song that firstly seems similarly straight forward, with Dylan marrying a woman called Isis and going on a quest for forbidden treasures with a stranger, who dies on the arduous journey. He visits tombs, caskets without promised riches and pyramids imbedded with ice. The metaphors and double meanings come thick and fast, tempting many to suggest this is a song about Bob's marriage. In my early teens, when I was totally obsessed with the whole record, I took it more literal. Now, I can perhaps see where the Dylanphiles get their hidden meanings. The casket bears no treasure, no dazzling jewels as promised. Is this life, or more specifically the marriage in question, not living up to the promises and aims the character originally had for them?

Musically, it swings along with strength, bulky drums and bass immovable. The acoustic guitar is low in the mix and the glamorous, romantic violin work from Rivera takes most of the attention. Live on stage during Rolling Thunder, the song really came to life. On the Bootleg Series Volume 5 instalment, it is for me the most stunning live performance I have ever heard by Dylan on a recording.

One of the brightest moments is the exuberant and poetic Mozambique, which bounces along vibrantly. Dylan and Emmylou duet with ease, as if their voices are merged into one, and Scarlet's beautiful violin passages dominate the sparse musical arrangement.

It's masterfully mixed too, with credit for that going to the great Don Meehan.

One More Cup of Coffee is the darkest and most mystifying song on the album, a descending ballad with enigmatic lyrics, a dazzling violin part and one of Bob's most impassioned vocal performances. He howls the lyrics wildly, the vivid descriptions that remain as shiver inducing after hundreds of listens. The occupants of this tale are gypsies, with the central character being a beautiful but cold, unloving woman the narrator feels no warmth from. The most startling line is when Dylan describes the old man's voice trembling as he calls out for another plate of food. Dylan wrote it while sitting at a table in the Greenwich Village night spot, The Other End, recalling a visit to the King of the Gypsies in the South of France, who had twelve wives and a hundred children. The version included in Renaldo and Clara is a wonderment too.

Oh Sister is slow and mournful, but it remained a regular visitor to Dylan live set lists for a while, suggesting that Bob had a lot of fondness for this one. With a similar chord pattern to Girl From the North Country (his Johnny Cash duet from Nashville Skyline), this is its own beautiful beast, with amazing vocals by Dylan and Harris combining forces to create magic.

A similarly treasured song in Dylan's long and varied canon is Joey, all about the brutal killing of gangster Joey Gallo. Dylan has claimed this was mostly written by Levy, as if to pass the blame on to his co-writer for the fact that Gallo is presented as something of a loveable rogue, a hero worthy of worship and mass mourning. However flawed the decision to put the mobster up on a pedestal was, this is an utterly enchanting song and the performance is almost heavenly.

The band are slow, paced and holding back throughout, until each compelling chorus where it all explodes together.

The song attracted controversy though. "Gallo was an outlaw," Rolling Stone pointed out, "in fact, only in the sense that he refused to live by the rules of the mob — it's as hard to be sympathetic to him as it is to be comfortable with Robert De Niro's crazy Johnny in Mean Streets. Is an intellectual Mafioso really that much more heroic than an unlettered hood? This is elitist sophistry of the worst sort, contemptible even when it comes from an outlaw like Bob Dylan."

"Joey's brother, unbeknownst to me, was sitting behind me in the control room of the studio when we were recording the song," Don Meehan told me, "Don De Vito said he was in tears the entire time during the seven minute long recording all about his brother being blown away. This was indeed a favourite cut and I also felt some emotional tinge as it went down. When we finally started to mix the album, I had felt all along that Joey needed some additional flavour added to it, especially since it was such a long record, but this would take some convincing of both Don and Bob, since Bob was so down on overdubbing. I convinced Don that we should add an accordion and some electric guitar and I had the perfect pair of musicians that could come in overdub parts in little or no time. Don called Bob, got the OK, and I called Dominic Cortese, a long time musician friend who is heard on all of the old Mitch Miller records, and who actually got me my first steady playing gig, when I came to town. Vinnie Bell would be the best for the guitar, so I called him. And we got the Italian flavour I had wanted. Actually, both of these guys would be considered the finest all around, versatile musicians anywhere. Dominic and Vinnie were at the studio within an hour and we ran

only part of the song down for them. We did one complete take and that was it. Seven damn minutes, one take. No mistakes, no redoes, no back tracking no overdubs, no bullshit. We mixed it and went on to the next."

The descriptive dynamism continues on Romance in Durango, a bright and gleeful detour into a fantasy scene involving an outlaw in Mexico. Levy and Dylan set the picture wonderfully, the musical shades enhancing the canvas. There's a similar fire and pictorial beauty to Black Diamond Bay, an upbeat gypsy rocker.

Sara is the closing number, one of Dylan's most exposed, honest and brave songs. Obviously a love poem to his wife, it was put down in one go right before her stunned eyes. She watched in the control room as Dylan sang with intensity and passion. It's a terribly moving performance, and was enough to save their crumbling marriage for a little bit longer. "You could have heard a pin drop. She was absolutely stunned by it," is how Levy himself recalled the incident.

The minor chords establish a mood of melancholia, enhanced by Rivera's heated violin parts, her finest on the whole album in my view. Dylan is totally open here, confessing that, among other revelations for his love, he wrote her Sad Eyed Lady of the Lowlands. Yet there is a nervous desperation to the vocals, and a sense of tragedy in the way the music is played out. The whole thing has a suffocating sad air about it. This sure isn't If Not For You, with the "please don't go" vibe utterly heartbreaking and bewitching at once. If it was Bob's aim to win her back once again with the song, then you can see why he might have succeeded, albeit briefly.

Sara aside, Desire doesn't have the personal, bitter and bare emotion that Blood on the Tracks has. It's a warmer ride of thrills and

far out adventures, played out with musical flamboyance and showy embellishments. Like Planet Waves, it stands as one of Bob's most prettily musical records. Special care, however conscious, is given to performance, while still keeping the unpredictable illusion of Dylan's mode of recording. Lacking the acidic bite of other work though, it's refreshingly sunny, with its moments of despair subtle and stylised.

"Sales on the Desire album went Gold in January 1976 and Platinum two months later," Don Meehan says, a survivor from the inside. "By May of 1999, it had gone to Platinum two million. And in my mind it was the best album Dylan had ever made, even to this day."

It was a huge hit at the time, while critics praised it too. Nowadays it's often overlooked in favour of his brutal confession, Blood on the Tracks, and suffers under the reputation of being too light. But it definitely has its fair amount of fans too. Rolling Stone called it a series of nightmares, depicting a man on the run from things. They have a valid point. If there is a darkness to the lyrics however, it's hidden covertly by the exoticism of the arrangements. They also, rather curiously, claimed it to be a special album only slightly ruined by Dylan's anti musical approach to recording. This seems an odd conclusion, as the album is anything but anti musical.

Desire sits right in the middle of the 1970s, a turbulent, restless, relentless and legendary era in Bob's career. There were avant-garde movies, aborted TV specials, massive US tours and marital warfare. Somehow, in the midst of this chaos, Dylan cut some of the finest music he would ever commit to tape.

DYLAN, THE BAND AND THEIR LAST WALTZ

"This film should be played loud!" These are the opening instructions from director Martin Scorsese, the man who committed to tape one of the most legendary concerts of all time, The Band's final concert, their Last Waltz. Organised by the legendary Bill Graham, the lavish event began at dinner time, with each of the 5000 guests enjoying a turkey dinner. There was poetry, dancing and readings before The Band took the stage at 9. Everything that happened thereafter is cemented on film for us all to see and behold, forever.

By the time the concert was held at the end of 1976, Martin Scorsese was already one of America's great filmmakers, with critical and box office hits like Taxi Driver and Mean Streets behind him. Robbie Robertson had been one of the many people impressed with Martin's earlier work, and approached him with the idea of capturing the

whole 76 shindig on 16mm film. However, as production got under way, the project became more elaborate and ambitious. Scorsese opted for the more cinematic and grand 35mm approach, bringing the film, and indeed the band themselves, to life on the big screen. "Somehow the 35mm brought out expressions of the band, the people on the stage and I decided not to shoot the people in the audience either," Scorsese said in a 1978 interview when the film was released. "We've seem so much concert footage and all you see is audience. But we do see the audience, but from their point of view."

Though this was the end, The Band weren't just going to slip away quietly. They wanted an all star night of rock and roll. Guests included Neil Young, who does a version of his classic track Helpless (side note: the coke around his nostrils had to be brushed out of the film, costing thousands of dollars), the great Van Morrison and a dynamite Muddy Waters. There is one guest however, who comes out quite near the end, who effortlessly steals the show. And that is Bob Dylan...

There are visual moments in Scorsese's long and varied career that are beyond compare in the canon of any truly great filmmaker, rich cinematic images that send shivers up the spine. Picture a blood soaked De Niro hanging on the ropes in Raging Bull as Sugar Ray Robinson comes in for the kill; Travis Bickle before the mirror in Taxi Driver; the Billy Batts death scene in Goodfellas; the shooting of Johnny Boy in Mean Streets. Among these is undoubtedly the second Dylan comes into shot during The Last Waltz. The camera pans down from above, revealing the iconic figure standing there with guitar in his oversized white hat, bushy hair in every direction, the polka dot shirt and leather jacket. The full band rendition of If You Let Me

Follow You Down is utterly stunning, blowing away Dylan's original into the dust. His highlight in the movie however, just has to be the magical take of the Planet Waves classic, Forever Young. Dylan sings his heart out, and he and The Band are so tightly woven together as a unit that it hurts. Look what these guys had been through together already. They had rocked the globe on the earth shattering 66 tours, redefined the rock and pop scene with the legendary Basement Tapes, toured the globe again to dizzying heights in 1974 and cut Planet Waves the same year. Their musical chemistry is evident from the first note they play together. Despite the weight of the previous guests, Dylan's arrival feels monumental.

Getting Dylan involved in the whole project however hadn't proved to be so easy. He wanted to perform out of respect for the group, but refused initially to appear on camera. Bob was editing his movie Renaldo and Clara at the time and thought his appearance in The Last Waltz would detract from his own masterpiece. How Dylan thought a concert extravaganza directed by Martin Scorsese and featuring iconic guests like Ringo Starr would be judged against a four hour experimental odyssey is anyone's guess, but Dylan definitely had reservations about the whole film. In 1971 he had been in the same frame of mind when agreeing to appear in George Harrison's Concert for Bangladesh film. Again, he was up for the cause, but got spooked upon arrival when he saw all the cameras, stating he hadn't been aware it was to be a show business extravaganza. It's proof of how much he respected Harrison that he agreed to appear on screen in the end.

The case of Dylan and The Last Waltz was rather different. Warner Bros. had only put up so much money due to Dylan's full

involvement. The fate of the movie itself rested on his inclusion, and Scorsese was panicking, unaware whether Dylan would come round to the idea or not. The only reason Dylan agreed to be put on screen was because Robbie Robertson ensured him that The Last Waltz wouldn't see release until *after* Renaldo and Clara. And with this in mind, Dylan's worries were eased, and he went out on stage to stun the crowd. However, there were still restrictions. Dylan only agreed to let Martin Scorsese shoot two songs for the movie. A frenzied Scorsese complied. "When Dylan got on stage, the sound was so loud, I didn't know what to shoot," Scorsese said in the book Scorsese On Scorsese. "Bill Graham was next to me shouting, 'Shoot him! Shoot him! He comes from the same streets as you. Don't let him push you around.' Fortunately, we got our cues right and we shot the two songs that were used in the film."

Though Dylan had been typically Dylanesque and frustratingly stubborn in its creation, it all worked out in the end. The film has gone down in history as one of the greatest concert movies, topping the lists time and again over the years. Official and decently filmed footage of Dylan in concert is rare. From the 70s we have the Bangladesh gig, the Rolling Thunder sequences in Renaldo and Clara, the John Hammond TV special, the Hard Rain concert, a few other bits and pieces (mostly bootleg) and The Last Waltz, definitely the best quality document out there from this era. Getting him on film these days is even tougher. Bob Dylan, ever the awkward, stubborn bugger.

RENALDO AND CLARA

The rock icon and grand cinema

The negative backlash received by Bob Dylan's grand cinematic experiment, the expressive and wonderfully mad Renaldo and Clara, always tends to baffles me somewhat. I often wonder, just what were these critics expecting? The film was a surreal collage, and after all, Dylan was already surrealist in his music, while his lyrics were both indecipherable and wonderful. There is a magic to much of his words, and in particular his choice of them, with Dylan in the centre like a wizard, weaving wild spells around your consciousness. Did critics expect Bob to make a simple, straight forward, linear movie? If so, they were misguided. Dylan's film is a massive, confusing and complex odyssey, using cinéma-vérité techniques, Fellini-esque assemblages and scenes of high octane stage performance. Dylan

hired playwright Sam Shepard for the script, but tossed aside a lot of his ideas (Shepard got something much more worthwhile out of it, his book, as he writes in the introduction to his Rolling Thunder Log book). It's comparable to the wild abandon of Dennis Hopper's The Last Movie, the film which deconstructed film itself. Hopper made it in the wake of Easy Rider's cultural explosion, committing commercial suicide in the process. Renaldo and Clara is not a movie, it's a collection of ideas and themes; some good, some bad, but all Dylan.

So what is Renaldo and Clara all about, many people ask. Identity? Fame? Personas? The film is actually a lot simpler than people make out, though I believe the level of enjoyment depends on how you can actually tolerate these sort of experiments. Without asking too many questions and letting the film's many shades and styles wash over you, a Dylan admirer can have a field day with Renaldo and Clara. It's a free flowing - at least on the surface - document of a snapshot in time, with unforgettable imagery, stonkingly good concert footage of Dylan's legendary 1975/76 Rolling Thunder Revue tour and scenes that may be hard/impossible to decipher. As Bob told Rolling Stone in 1978, "There's Renaldo, there's a guy in whiteface singing on the stage and then there's Ronnie Hawkins playing Bob Dylan. Bob Dylan is listed in the credits as playing Renaldo, yet Ronnie Hawkins is listed as playing Bob Dylan." Of the film, he also added the wondrously enigmatic statement, "Bob Dylan didn't make it. I made it."

Though reactions at the time were pretty intense. New York Times seemed to have enjoyed it for what it was, although they weren't afraid to point out what they felt were the flaws. "Mr. Dylan has

always been elusive; that's no mean part of his charm. But his best work, like the Blood on the Tracks album released a couple of years ago, has derived its momentum from alternating currents of passion and restraint, from conflicting impulses to repress and to reveal. Renaldo and Clara addresses this apparent contradiction so passively, even cold-bloodedly, that it seldom has the urgency it needs. The film is full of connections to be made and riddles to be solved, but it approaches these things so dispassionately that the viewer has little choice but to follow suit. Even though Mr. Dylan makes it clear that he in no way wanted to make a concert film, the footage of him in performance provides not only the film's most electrifying moments but also its most emblematic ones. On the Rolling Thunder tour, Mr. Dylan performed in whiteface, and he is photographed here in tight closeup, singing so ferociously that his sweat melts the makeup; the film's sense of a person at war with a mask is never more riveting than when the camera studies Mr. Dylan's face as he sings. The film contains more than its share of dead weight, but it is seldom genuinely dull. Following a pattern of linear thought is clearly not one of the film's concerns, but maintaining a constant degree of intensity should have been; this way, by carelessly commingling very complex and suggestive episodes with very flat and simple ones, the editing continually throws an already befuddled viewer even further off balance. Interludes like the culminating meeting of Mr. Dylan, Mrs. Dylan and Miss Baez, at once quite rarefied and in an atmosphere that is amusingly mundane, and an exceedingly one-note segment devoted to Hurricane Carter, are so incompatible that they simply don't belong in the same movie."

Renaldo and Clara is not alone in the canon of rock icons side lining into film, or film experimentation at least. Like Bob Dylan's surreal Renaldo and Clara, fellow icon Neil Young's 1972 movie Journey Through the Past is a challenging, rambling but ultimately fascinating test of naivety, that either fails or works, depending on your view. For me? It's a bit of both. Shot in 16mm and following Young around on tour, there are also various invented scenarios, fantasy sequences and TV broadcast footage of Buffalo Springfield in early action. No Young fan should feel short changed, as the film features a lot of vintage footage of the great man we otherwise wouldn't be able to see. But most folk will be either confused or bored by the film.

Once again, as I often tend to, I am drawn into comparing Neil Young with Dylan, unarguably one of his closest contemporaries. Like Renaldo and Clara, Journey Through the Past contains scenes and sequences which are very hard to decipher, if indeed there is anything to decipher at all. While Journey Through the Past predates Dylan's odyssey by a fair few years, there are a lot of stylistic similarities. Renaldo and Clara rambles, scenes last for up to ten minutes at a time, and for the most part very little seems to be happening. The same goes for Journey Through the Past, and by Neil's own admission, it was intended to be totally lacking in structure, rather than being a tightly constructed piece with a narrative and a clear direction. He considered the idea of just having a camera following him around good enough, doing the things he tended to do, like going to a radio station to do an interview and just hanging around with friends. This aspect of the film really does work well, and if some viewers and critics found these scenes boring, they

missed the point. Young intended these scenes to be mundane, presenting us with a slice of his real life, anything but cinematic. He was, to put it one way, a bit like a kid on Christmas day, playing with his new toy - a movie camera. Like Paul McCartney during the Magical Mystery Tour era, Neil was getting off on filming everything he fancied filming, and some of the results are fascinating.

Unlike Renaldo and Clara though, Neil's film is not pretentious, at least not in my view. That's not to say Dylan didn't make an interesting film, because he surely did; it was just that some of the themes seemed a little forced and, it has to be said, self absorbed. But when you are Bob Dylan, self absorption is a good thing, and something a lot of people are going to be interested in. One could argue however, that the lack of a one true Dylan in the film is actually anything but self absorbed. Bob is perhaps stripping away his own myth before the camera. The multiple Bob Dylans who pop up in the film made it clear that Renaldo and Clara was all about identity, as Bob himself said, or perhaps about losing ones identity in the face of a terrifying fame. There are some truly odd sequences, such as the cringe worthy scene when Bob, his wife Sara and ex flame Joan Baez all have a rather uncomfortable encounter in his hotel room. Journey Through the Past has its fair share of fantasy sequences, but they are done with clear humour and the sheer thrill of piecing together some kind of movie. Neil was definitely a wide eyed filmmaker, who knew very little about technique but admired experimental cinema. Journey Through the Past comes across as a naive document of an era, assembled by a man at the height of his fame. Renaldo and Clara, like Dylan himself, is more contradictory,

mysterious and intriguing. For all its flaws - however crucial they may be or not - it's a fascinating trip.

Both films were massacred by the critics, who perhaps took the experimentalism a little too literally. Not that Young or Dylan cared what the critics said mind you. Then again, they must have at least felt insecure about the films, seeing as they were both removed from circulation and neither have been widely commercially available since their initial limited releases. You do have to consider that Young and Dylan put a lot of his own money into Journey Through the Past and Renaldo and Clara respectively, and as true creative souls, they were toying with cinema, messing around with the format and seeing where it took them. It proves that self indulgence can produce good, if dividing, results.

If one can see Renaldo and Clara as an extension of Bob Dylan as poet, writer, song writer, rock star, celebrity and painter, then we can learn to understand it and appreciate it for what it is. As we learn of filmmaker David Lynch in the startlingly good documentary on him, Lynch One, he is not just a film director; he's a compulsive creator. he writes, makes music, photographs the interiors of old factories, paints, chops and dissembles sculptures and makes, most famously of all, surrealistic films that achieve mass acclaim. He speaks of the need to create, the enjoyment to be had in creation, and the importance of focusing on the doing of the project, rather than the results or reception. Any true creative person should enjoy the moments of the making, put the finished result and impending critical analyses aside. Again, like Dennis Hopper, Dylan's film work stands as another appendage on the whole body of work. Hopper, a painter, actor, director, photographer and writer, was forever looking

to achieve perfection, to be a genius. This, in effect, was his mistake. He became swallowed up in his aspirations, his own ego and the end result became an obsession which haunted him relentlessly through the creative process. Lynch says if you don't enjoy the creation, do something else. I view Dylan in with Lynch's mode of thinking. He's not trying to be the best (Lynch says, again, to put this idea out of

your mind), he is experimenting, toying and creating, never defining or explaining his aims, views or aspirations. He makes the film, does the painting, writes the song, and puts it out there, moves on to the next thing and forgets about it. It's the way of the true creative spirit. Considering it from this angle, and Renaldo and Clara becomes a much more relatable test. Is it the need to be great at everything? Of course not. But it's to try everything, every form, every medium, no matter how successful the end result might be in the eyes of others.

Bob explained his supposed mission with Renaldo and Clara and seemed to insinuate it was a much simpler picture than people thought it to be. "It isn't just about bus stations and cabarets and stage

music and identity," Dylan said, "those are elements of it. But it is mostly about identity — about everybody's identity. More important, it's about Renaldo's identity, so we superimpose our own vision on Renaldo: it's his vision and it's his dream. You know what the film is about? It begins with music — you see a guy in a mask [Bob Dylan], you can see through the mask he's wearing, and he's singing "When I Paint My Masterpiece." So right away you know there's an involvement with music. Music is confronting you."

I feel Dylan did, in some very strange way, make a very straight forward film. If you switch off all your grand views of Dylan the man and the myth, forget all film conventions and the rules you had learned about cinema before switching play, then you are going to have a good time. It's a film of ego, fame and identity - loss of identity, misplaced identity.

"Possessiveness," said of the scene where the real Joan Baez and Dylan's wife Sara sit together, with Dylan in the middle, somewhat awkwardly. "It was a self-focused kind of question. And earlier, one of the women in the whorehouse talks about the ego-protection cords she wears around her neck. Do you remember that? Did you notice that Renaldo was looking at the newspaper which had an article on Bob Dylan and Joan Baez in it? Joan Baez and Bob Dylan at this point are an illusion. It wasn't planned that way. Joan Baez without Bob Dylan isn't too much of an illusion because she's an independent woman and her independence asserts itself."

That scene is one of the film's many highlights, a field day for a Dylan dissector and a nightmare for anyone wanting to crack the Bob enigma. And that said, if you are looking to reveal the genius inside his head by watching Renaldo and Clara, then you're barking up the

wrong tree. Even though I don't find it hard to watch, and can kind of let the whole abstract flow and non-structure wash over me, this will only make Dylan more of a confusing, unreachable enigma to you.

However, in that 1978 Rolling Stone interview, he was as revealing as he could be, especially about his surreal, misunderstood masterpiece. "I know this film is too long," he added. "It may be four hours too long -- I don't care. To me, it's not long enough. I'm not concerned how long something is. I want to see a set shot. I feel a set shot. I don't feel all this motion and boom-boom. We can fast cut when we want, but the poser comes in the ability to have faith that it is a meaningful shot. You know who understood this? Andy Warhol. Warhol did a lot for American cinema. He was before his time. but Warhol and Hitchcock and Peckinpah and Tod Browning... they were important to me. I figured Godard had the accessibility to make what he made, he broke new ground. I never saw any film like Breathless, but once you saw it, you said: "Yeah, man, why didn't I do that, I could have done that." Okay, he did it, but he couldn't have done it in America. I don't know what to tell you. In one way I don't consider myself a film maker at all. In another way I do. To me. Renaldo and Clara is my first real film. I don't know who will like it. I made it for a specific bunch of people and myself, and that's all. That's how I wrote Blowin' in the Wind and The Times they are a Changin -- they were written for a certain crowd of people and for certain artists, too. Who knew they were going to be big songs?"

I feel the fact that Dylan attempted to make something different - or more to the point, a different kind of film just happened to come out of him - is admirable, and had he made your average rock star cross over into film, ala Sting, then we would have been very

disappointed. Dylan had helped put together that great lost tour film of his, Eat the Document, itself a confusing, jumbled film with a strange edit, but one that also captures the unpredictable excitement of mid 1960s Dylan on tour across the UK. Like its predecessor, DA Pennenbaker's influential tour road flick Dont Look Back, it captures iconic Bob in all his young glory. His role in Sam Peckinpah's previously discussed Pat Garrett and Billy the Kid was a similarly intoxicating, highly watchable display of natural charisma and mystique, very different to the tour movies, but a sure example that Bob had screen presence in a more conventional way. Renaldo and Clara, Dylan's vision entirely, is more like an expanded song, cloudy and multi layered, but also very simple if you want it to be. As with his songs, we pull out our own meanings, people fill books with interpretations and each track means something fresh to the next person, something personal too. Seeing Renaldo and Clara as an extended song - a four hour song, no less - makes much more sense and actually pulls the film together. It's a collage of ideas, themes and images set to varied music. The Rolling Thunder tour scenes are not just live performance; Dylan is in mid-performance here too, with tribal white face paint and Mad Hatter eyes glaring out at the crowd. It's one of many performances he gives in the film; actor, writer, singer, director and Bob Dylan. These are all parts he is playing in Renaldo and Clara.

Musician Arlen Roth ended up in Renaldo and Clara in a couple of scenes. He told me at length all about it:

"In 1976, deeply steeped in the NYC and also the Woodstock music scenes, I had been doing a lot of performing and recording with Folksinger/songwriter Eric Andersen. On this one particular occasion,

while I was in New York, Eric called me up at my apartment on the Upper East Side, and told me; "Erlin (that's how his upstate NY Buffalo accent made my name sound!), tonight, the survivors of the '70s will be decided, and I want you to be there with me!" Well, at first I had no idea what this crazy kind of statement was meant to infer, but soon after that he said that Bob (Dylan) was most likely going to show up as a surprise at Gerde's Folk City that night, and we needed to be there and to be prepared to play. He promised nothing, and said that it was a secret, but that I should come down and play with him, and who knew what else was to happen!?

"Needless to say I was fairly excited at the possibility of meeting, playing with or even seeing Bob Dylan, since it was a time when he truly reigned supreme, and he was one of the most elusive and enigmatic figures in all of music, Folk, Rock or otherwise. Gerde's Folk City was a legendary club in Greenwich Village that was apparently the scene of Dylan's first ever NYC gig, and he wanted to sing Happy Birthday to Mike Porco, the owner and the man who gave him that first gig. Or at least this was the initial "front" of this gig, which was supposedly going to turn out to be a much bigger deal.

"After some thought, I figured I may as well go to this thing. Eric Andersen couldn't be counted on to be too reliable or "together" in those days, but he seemed to have some inside info on this "gig", and I was never one to miss any opportunities like this. So, in a half-hearted gesture of "nothing may happen", I grabbed my little tiny Pignose amp (the same one we used years later in the film, Crossroads), my recently acquired 1953 Telecaster, my lovely 1939 Martin 000-18 I got from Ry Cooder and hopped on the subway and went down to The West Village and to Gerde's. I got there nice and

early, even before Eric, and as I placed my tiny Pignose onstage I started to notice unusual things. Right away large and very professional movie cameras were being set up, lighting was being put in place and some very good mics were being put in front of my "not very good" amp. This kind of upset me, since I figured that if this was going to really be such a heavily-covered and recorded event, I should've had a finer and bigger amp like my Fender Deluxe Reverb, which would've made me sound a lot more like the "me" I would want Dylan and all the rest to hear! Regardless, I just figured things would work out, and that at least I was playing there, and there seemed to be no other electric amps being set up at the time.

"Before long, a very crowded, but sort of "misfit" kind of audience started to fill the place up, and we were already well setup onstage and ready for whatever was about to happen. Then, lo and behold, Dylan and his crazy entourage showed up, taking the place over like a travelling band of gypsies! He was with Joan Baez, who I had always loved and admired, Rob Stoner, a New York bass player, Ramblin' Jack Elliot, who I had actually been hanging out with the year before when I was touring with John Prine, Roger McGuinn and Dylan's apparently perennial "court jester" Bob Neuwirth, also someone I had come across at various drunken L.A. parties and jams during that "John Prine" year.

"Soon enough. They took the stage, and Dylan looked straight at me and asked if he could borrow my Martin. I said "sure", and then Joan Baez said something to me like, "you'll be sorry you let him borrow it!" Then he looked at me and said "no strap?" and I said "that's right, no strap!" This was a guitar I always preferred to sit down with when I played, and in keeping with its originality, it had

not added strap buttons. Then I watched as he and Baez and a few others broke into a rather disjointed "Happy Birthday" sung to Mike Porco. Stoner had only an upright bass with him, and he immediately broke the bridge on it, and there was no more bass to be heard! At the same time, as per Joan Baez' warnings, Bob Dylan had put a deep gouge into the back of my Martin that I instantly became very proud of, and showed off and displayed for years! Upon seeing the bridge break on the bass, I ran to the old, wooden phone booth in Gerdes, called my friend and partner Tony Brown, a wonderful bassist who had done Dylan's Blood on the Tracks album 2 years before and told him he'd better get his ass down there with a bass and amp right away, so he could take his rightful place onstage and also re-kindle his relationship with Bob, but alas, he refused, once again letting his career flounder, his bitterness fester and as many people do, allow his life to turn on a dime! Tony was never musically heard from again...

"Disappointed, but still raring to go, I quickly jumped up onstage with my Tele, and started to basically play along with whatever they were singing. What an exciting moment, as I firmly held my position onstage as a total parade of artists started to jump up there! I mean I was playing interpretive Tele behind Alan Ginsberg's poetry (fully realizing that he was the same creep who appeared out of the darkness in the subway as I went to school in Harlem, acting like a total pervert towards me), then I played free-form Telecaster behind Patti Smith's ramblings, then McGuinn singing Chestnut Mare, Bette Midler and Buzzy Linhardt, Ramblin' Jack Elliot, who I thought was just terrific, and several others. The whole time, Eric Andersen tried to also stay on the stage, but he was just too far out-classed by the actual "players" who were up there, so he finally sat down.

Meanwhile, this whole time, there was a huge Birthday cake that sat in front of the stage with a huge knife just waiting on top of it!

"As Dylan and his crazy crew kept messing around in the corner, all of a sudden the great Phil Ochs, another renowned folksinger, took the stage. He started to play, literally falling down drunk, and Dylan suddenly stood in front of me, closing his eyes and deeply listening and "kvelling" as he heard me play. At this same time, Neuwirth was telling Bob all about me in his ear. This was perhaps the high point of the night for me, as I thought I was finally reaching the very set of ears I wanted to reach! Then, Ochs abruptly turned around and said "no background!", meaning none of us "backup" players should play. I should also mention that a fairly "green" T Bone Burnett was playing piano that night too, long before he became the well-respected producer he is these days!

"So then, minus any "background" Phil Ochs went on to playing his song, and as soon as he launched into singing, some guy in the audience who had been sitting all alone, suddenly grabbed that big knife and went right at Ochs' chest with it! Ochs backed up into me, slurring "hey, there's a guy with a knife…..", and just as that occurred, Eric Andersen, the man who brought me into this mess, tackled the would-be assassin and the guy went face down right into the cake! As soon as that went down, all you could see was Dylan and his band of misfits filing out of the place just as quick as they could. Ochs stopped playing, and said "Bob, Bob, please don't leave, please!" Dylan actually stopped for a second, turned and said something like "I'll be right back", but of course, he never did come back at all, and everyone was left to ponder what had really just occurred. Were we

all now the "survivors of the '70s," or were we just lucky to still be alive?!

"One odd aftermath of all this happening was we were summoned to somewhere on 8th Street where we waited outside of a building for what felt like an eternity for the "after-party party" that was rumoured to be also with the elusive Bob, but nobody really knew. After some uncomfortable waiting I remember turning to Patti Smith and saying to her, "so do you think Bob is going to show up?" She simply reacted by giving me the sweetest angelic look and cupped my face in her hands, as if to say "he's just so innocent and pretty, isn't he?" She never said a word, but it seemed to communicate so much. Bob never showed up again, and we all went home into the 3AM, 1976 New York night.

"As it turned out, all this hoopla was Dylan and his folks kicking off their Rolling Thunder Tour of that year, and using the "birthday party" simply as a front for this tour initiation, and were filming it as part of a movie that was later to be called Renaldo and Clara. Only some minimal stuff remained in the film from this night which was a shame, because that one night at Gerde's alone could've been an entire film unto *itself!* I ended up in the movie in a long scene playing with Ramblin' Jack, but was supposedly in more scenes but never got to see during its short-lived run in the theatres, since I was on the road when it came out. And oh yes, Phil Ochs hanged himself the next day after that performance."

Another legend present for the film and the tour, was Mr Larry "Ratso" Sloman, the famous writer and journeyman. He penned a book about touring with Bob, On the Road with Bob Dylan, and even appeared in Renaldo and Clara.

"We knew about the movie back in the Village before the tour took off," Ratso told me recently. "He filmed a party scene at a friend's loft on Bleecker Street and then filmed Mike Porco's birthday party at Folk City. So we knew there would be documentation of the tour, we just didn't know it would morph into Renaldo and Clara. I don't agree that it was loose and free. He had Sam Shepard on the tour, writing scenes for the movie, most of which Bob discarded. But he had a very well defined notion for the film and while it was open to modification I wouldn't call it loose and free."

With it being such a heady time, I dared to ask Larry his highlights of the filming of Renaldo and Clara. "Just memories like Bob giving me his gloves up in Canada when it was freezing and I was taking notes for my book after they shot a scene," Ratso told me. "Another

scene in a train station in Toronto where Bob borrowed my long coat, my raccoon hat, and my black briefcase and wore them for a scene he was shooting. And, of course, our famous exchange after shooting a scene and I was about to drive him and Sara back to the tour when I asked him if he meant warehouse eyes, as a verb, or a distinct image - warehouse eyes, Arabian drums. Sara piped in that she always wondered about that too and Bob just laughed. I first saw it in a movie theatre, the long version. I loved it. I thought it was genius. I especially liked my interviews in the diner. I never had the nerve to bring up the film after some critics hated it so much they wrote that maybe he should have died before so his legacy wouldn't be tarnished. But I don't think any of them dissuaded him. He's tough."

I know I am probably in the slight minority in admiring Renaldo and Clara as a movie, for even devoted Dylanites either hate it or can't make their way through it. As a fan of deconstructive cinema like Dennis Hopper's The Last Movie, I view Dylan's film in a similar light. If you're not expecting Star Wars, and want to hear a lot of great music - some of it by Bob - set to surreal, playful and strange imagery, then you will definitely enjoy it. The only thing everyone has to admit though, is that it's probably an hour or two too long. But hey, it's another hour or two to be baffled by Bob Dylan magic.

Though it was met with bafflement, some reviewers seem to have reassessed the film now. Even though it is not commercially available, it can be seen, and sites like Nerve are glad of the fact. "Bob Dylan's epic 1978 film Renaldo and Clara," they wrote, "a four-hour fever dream of concert footage, documentary, narrative pieces co-written by Sam Shepard, is nearly as legendary as the Rolling Thunder Revue concert tour that fuelled it, excessive in every way,

doomed by critical consensus as an impossible-to-sit-through failure. I'd always been a little bit afraid to watch it, honestly. But, thanks to the internet, I stumbled across a stream of pretty decent quality. So I popped a bottle of champagne, sat down, and clicked play, expecting the worst. And to be fair, twenty minutes in, I was already baffled. The camera work was shaky, the dialogue mumbled, Dylan's band wearing masks and making jokes I couldn't seem to get. An extended scene of singer David Blue playing pinball in front of a swimming pool, talking about the folk scene at the Gaslight. So far, so weird. But then something amazing happened. Cue Bob Dylan in the first of a series of remarkable hats, kissing a woman while playing guitar, in what seems to be the back room of a mechanic's garage, while the mustachioed mechanic watches. What follows is a series of bizarre vignettes and rock and roll, rife with religious imagery, angels strumming violins, a multitude of Christ statues, and Joan Baez playing some sort of temptress goddess of love. Renaldo and Clara is an absolute joy, a journey through the wild dreamworld mythology of one of my favourite artists of all time, a land where poets and gods and bandits go stalking down the road, seeking after your soul. I'm grateful for all two hundred thirty-two bizarre, wonderful, frustrating minutes. Also Harry Dean Stanton and Joan Baez make out while Dylan rides around on a horse. That's pretty cool too."

And there is the answer. It's pretty cool. And it's Bob Dylan. So what's not to like?

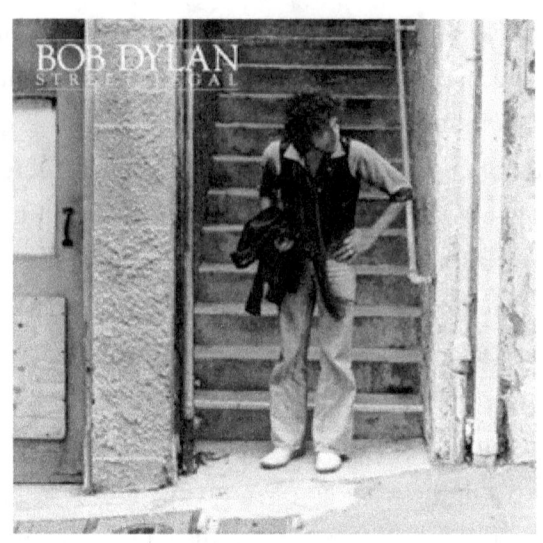

STREET LEGAL

The great forgotten Dylan record of the 1970s just has to be Street Legal. After all, 73's Dylan is not so much forgotten as buried, and many people believe rightly so. But Street Legal is an undeniably strong piece of work, often unfairly overlooked. The level of quality reflected in the sales; it was a huge hit in the US and hit Number Two in the UK. The critics however, were far from impressed. Coming after his last studio albums Blood on the Tracks and Desire, an intimidating double whammy that even the best like Dylan would have trouble matching, Street Legal does feel underwhelming when compared to those two masterpieces. On its own however, it stands rather proudly, though it rarely soars to iconic Dylan heights.

Recorded after Dylan's high profile, crowd pleasing 78 tour, Street Legal is slightly under produced, if it's been produced at all. Credited to Don De Vito, it's not very clear what he actually did to get the

credit. The absence of Don Meehan, who worked magic on Desire, is very much felt here. However, the songs are strong and Bob is in superb voice. What's not to like?

Changing of the Guards is classic Dylan, slightly muted in its mix, but powerful all the same with his soaring vocals supported by the rich backing singers. It is clear from the first few seconds that Dylan is in a new territory here, an area he hadn't explored before. The three backing singers add a lot of dynamism, as do the sax solos in the verse breaks. The song has a strong chord sequence, allowing Dylan to really flex his singing muscles, and show what a powerful vocalist he really is. As for the words, do they really paint the portrait of Dylan the journeyman? The troubadour of "sixteen years" about to discover the joys of The Lord, and in turn, himself? There is a biblical vibe about the song, and it has an epic stature. Whether personal or more general, it's a blasting opener.

There's a groove to A New Pony, a laid back funky vibe with bongos, chugging guitars and excellent back up vocal parts. He's always been a master of his own mutated form of the blues and this is a really cool addition to that sub genre in Dylan's catalogue. There are some tasty solos in here and his voice is superb throughout. With the references to the Devil, I put it forward that this may just be a precursor to Bob's impending New Born Christianity. Or maybe that's too easy. After all, the climbing on the pony suggests something sexual, and the "new" implies a fresh lover. It's more cryptic than that.

The brass and string opening to No Time to Think is reminiscent of mid seventies Lou Reed, but as soon as our hero opens his mouth, we are clearly in Bob Dylan land. A beautiful melody made all the more effective by the four voices working together (one of these voices is,

of course, Dylan's future wife for some time, Carolyn Dennis), it's a wonderful song, unjustly buried on a dismissed album. I also love the feel of tracks like Baby, Stop Crying, for musical reasons alone, no matter what the lyrics may be about. So many people have attempted to decipher his words, but the truth is any interpretation is personal to whoever is making it. There is a way you can simply enjoy Dylan's music for what it is, just as one can with other artists. Take a step back, relax and listen to it on the level of pure sound, rather than trying to pick out the meaning of life. Musically it's brilliant. The chorus is utterly powerful, while the band are meaty and tightly knit.

The melancholy feel of Is Your Love in Vain is satisfyingly moody, with the beautiful brass reminding one of the final day of a closing mine pit. Dylan delivers a clear vocal effort, melodiously rich and bold. Is this a message to Sara, his estranged wife? Perhaps. It could also just be a general song of heartbreak and heart ache, set to a wonderful musical back drop. The bridge is one of Bob's finest moments, with the voices harmonising to maximum effect. I honestly feel that any Dylan fan critical of this record is mistaken. OK, this isn't the high speed ranting territory of Highway 61, but it's a mature, beautifully written song of lost love and regret. The brass only adds to the moving quality too. Structurally, and in its sad, weighty atmosphere, it's a clear sign that Dylan only improved as a songwriter, both technically and unconsciously, as time went on.

The similarly wistful Senor (Tales of Yankee Power) is absolutely wonderful, bringing to mind a Mexican village under threat of the USA. This remarkable song, one of Bob's best from the whole decade in my view, was actually inspired by the sight of a haggard old man he saw on a train from Mexico. "He must have been 150 years old...

Both his eyes were burning, and there was smoke coming out of his nostrils." Musically it's emotionally stirring, as well as being lyrically unforgettable, with bold drums, lovely mandolin and some spiky guitar solos; not to mention that mournful trumpet, which dances gracefully with Bob's six string.

Despite it being what I feel to be a well played and effective LP, it was roundly panned. Greil Marcus of Rolling Stone used such words as wretched in his review, and also commented, "It saddens me that I can't find it in my heart to agree with my colleague Dave Marsh that Dylan's new record is a joke, or anyway a good one. Most of the stuff here is dead air, or close to it. Ah, but the singing! The singing, which on other records has redeemed lines nearly as terrible as those I've quoted — what about the singing? Well, Bob Dylan has sounded sillier than he does on Street Legal (Big Yellow Taxi), more uncomfortable (The Boxer) and as disinterested (Let It Be Me), but he's never sounded so utterly fake. The most interesting — if that's the word — aspect of Street Legal is its lyrics, which often pretend to the supposed impenetrability of Dylan's mid-sixties albums, the albums on which his reputation still rests. But the return is false. I mean, if I want a joke, I'll listen to Steve Martin sing King Tut. That line, 'He gave his life for tourism,' is really funny."

Seeing as Marcus took any chance he could to give Dylan a good smacking, specifically about his song writing and singing, I can only assume that Marcus is an endlessly talented man himself, otherwise he would have no real right to lay into Dylan so mercilessly on Street Legal. Marcus and his ilk are so hung up on that mid sixties, mercurial Bob Dylan image that they can't see past the end of the Summer of Love. Why not appreciate that Dylan is a man and artist

who grows and evolves throughout the decades, rather than someone standing still? Marcus may enjoy clinging on to the time of his youth, but he is far more boring than the music he is verbally pissing all over; though I have to admit, I respect Marcus (he's been writing longer than I've been in existence) and always enjoy reading his words on Bob, even though his views are totally different to mine. Yes, Dylan made some masterpieces in the 60s, but no one, not even Bob, could possibly keep up to that level of creativity. Those lyrics came from a speed frenzied lunatic, a stream of surreal word play that no one in their right mind could have penned. The truth of the matter is that he's made just as much interesting music after that period. Street Legal, while no Blonde on Blonde, is still a very good album, made all the more remarkable when you consider it comes from a man, who at that point, had been releasing albums for close to two decades, and wasn't far off the age of 40. To expect one man to live up to the myth of BOB DYLAN is unfair.

Dylan actually gave Rolling Stone an interview in support of Street Legal, although it was to writer Jonathan Cott, and certainly not Greil Marcus. "They had the nerve to run the reviews they did on Street Legal – why should I give them an interview anyway?" Dylan asked at the start of the conversation, and who can blame him? They had printed a mocking hatchet job, one man's opinion of the record being put forward as the one shared by the whole publication.

"These are things I'm really interested in, and it's taken me a while to get back to it," Dylan says in the same interview, of the album and song writing in general. "Right through the time of Blonde on Blonde I was doing it unconsciously. Then one day I was half-stepping, and the lights went out. And since that point, I more or less

had amnesia. Now, you can take that statement as literally or metaphysically as you need to, but that's what happened to me. It took me a long time to get to do consciously what I used to be able to do unconsciously. It happens to everybody. Think about the periods when people don't do anything, or they lose it and have to regain it, or lose it and gain something else. So it's taken me all this time, and the records I made along the way were like openers – trying to figure out whether it was this way or that way, just what is it, what's the simplest way I can tell the story and make this feeling real. So now I'm connected back, and I don't know how long I'll be there because I don't know how long I'm going to live. But what comes now is for real and from a place that's... I don't know, I don't care who else cares about it."

Retrospectively, and thankfully. it's seen a kind of revival in appreciation. Stereogum for instance put it in their top ten most obscure Dylan album list a few years ago, writing, "This is deliberately Dylan's showbiz record. Dylan delivers on Street Legal his own particularly demented notion of what a big Vegas run might sound like. What results is one of the strangest hybrids ever committed to record: densely layered songs ladled with sundry horns and wailing backing singers. All of these crowd the legendarily poor and slapdash mix (which was remastered to great effect in 1999) and ultimately make for a challenging and claustrophobic listening experience."

Challenging and claustrophobic shouldn't be appealing facets, especially when it comes to music, but enjoyment comes in the strangest forms. A weird, muted and wonderful little album like this is certainly one of those strange forms.

BOB DYLAN
LIVE ARTIST IN THE 1970s

"Dylan is trying to establish there is still a Dylan around."
- Scott Young (father of Neil), 1974

Of all the eras where Dylan has been a prolific live performer - in every decade he's been a recording artist, no less - the 1970s are perhaps the most legendary and varied of the lot After all, take a look at his journey so far up to that point. Bob had started doing the folk centres, cafe bars and mini festivals in the early 1960s; he had taken Newport by storm, brought it more rabid media attention than it had ever garnered before (he actually brought it into the arena of pop star fame); and then he invented folk rock with his mid 1960s world tour, backed by The Hawks, soon to be The Band. It was a wild

decade for sure, but the 1970s proved to be even more extraordinary, although for more quirky reasons, rather than earth shattering ones.

His 1974 world tour with The Band was one of the most lucrative of the 1970s, a massive undertaking which unfortunately saw most of the profits wasted on ill judged investments. Then of course there was the Rolling Thunder Revue Tour, running from 1975 into 76, one of his most exciting and unpredictable jaunts. It was widely praised, although unfortunately there were only US shows. Still, it has gone down in legend as one of the wildest tours of all time. His 1978 World Tour divided fans and critics alike for its crowd pleasing showbizzy vibe, but today sounds good on the various live documents we have of it. Each tour then, whichever way you look at them, served its own purpose. The latter was largely a money making venture, but when you consider his divorce, the money that went into the Renaldo and Clara movie and other expenditures, maybe Bob did need a little boost in his accounts - though I would never suggest he did it for the money. There is also The Gospel Tour, which saw out the 1970s and ran into 1980. These monumental ventures present four sides of Dylan the live performer - the icon, the artist, the showbiz superstar and the spreader of God's wisdom.

The 74 tour was at one point the most popular and successful tour of all time, with advance orders for tickets at an unprecedented 5 million. The likelihood of seeing Bob Dylan at that moment in time, that great counter cultural icon and voice of the 1960s, would have been like catching a glimpse of Big Foot. Bob didn't tour, and hadn't done so since the mid 1960s, nearly a decade earlier. He had made the odd appearance, like the Bangladesh Concert and Isle of Wight Festival, but other than that he was a rarity on the world stage. Planet

Waves was hot on the charts too, his first new album of self penned material in four years. No wonder they came from every corner to see him.

Much had changed in the eight years since his last tour. Dylan was no longer a speed freak stick insect with an acidic tongue and attitude problem; he was a fully developed man, here to play the classics for the crowds who had come to see their idol. Backed by The Band, he gave the punters what they wanted. Beginning on the 3rd of January and ending on the 14th of February, the 40 date trip was hailed as a grand spectacle. Dylan was back, a relevant voice once again, singing songs that mattered in an age of glam glitter and cock rock posers. Here he was, the man who had given rock, and for some people life itself, a whole new meaning, He was in his thirties now, married and experienced, almost respectable. Their hero had grown up, and they had grown up with him. The venom aimed at Self Portrait was a thing of the past. Dylan was their genius once again.

This monumental tour was not going to pass by undocumented, with bootlegs and an official release coming to light soon after. The resulting live set was Before the Flood. Capturing the excitement of this huge "comeback" tour, it's a solid set, essential listening for anyone wanting to experience a classic Dylan live set. The vast, 21 track album starts with a scratchy, raw and rocking rendition of the Blonde on Blonde classic Most Likely Go Your Way (And I'll Go Mine), with The Band thumping away solidly behind a clearly euphoric Dylan. It's classic after classic territory, a bit like a Greatest Hits record to remind you of Dylan's song writing force, and the performances are top notch throughout. Lay Lady Lay is given the solid 74 treatment and is one of the best live recorded versions of the

track I've heard. Similarly, Rainy Day Women #12 and 35 is all high energy, with very little of the rag tag quality of the original recording, but instead a generally more all guns-a-blazing rocking gusto feel to it. We are even treated to a compelling version of Ballad of a Thin Man, a track Bob did with The Band (then The Hawks) back on the mid sixties tours to great effect. Here though, a Dylan over 30 sounds mature, a more well rounded artist who seems to understand things a little more. He sings the songs like a man of experience, a traveller who has been there, done that and seen it all. It's a voice that's lived through these songs and come out the other end.

Although it is not evident from recordings, or photos for that matter, Dylan hated the tour and couldn't wait for it to end. He said it was good for the bank balance, but "wasn't a passionate trip for any of us." But it reminded the world that Dylan was still around. As writer Scott Young observed, he was in strong, fine voice throughout the trot. And those songs, sung by the man who wrote them, needed to be heard again, reminding the rock audience that sixteen minute shirtless guitar solos weren't the only way to reach people.

If Tour 74 hadn't been a very passionate one, his next tour surely was. Enter Rolling Thunder Revue. "I can say that pretty much every show and even days off were filled with highlights and memorable moments," Scarlet Rivera recalled to me, looking back on her role in the Rolling Thunder Revue. "Right from our very first show in Plymouth, Massachusetts in a charming small theatre. I had never played in front of an audience that big... and much bigger was yet to come. I was quite nervous; back stage I painted a symbol on my forehead and put on my sunglasses even though it was a night concert. Bob bent down and gave an A to tune (there is a photo of

this moment out there), his calm presence and warmth helped me move into a powerful place within before I hit the stage... Plymouth, by the way, is where the first pilgrims to America landed, so it was a well chosen symbolic place to begin the Rolling Thunder tour."

Dylan had always loved the idea of a travelling band of musicians and artists, hitting the road for loose concerts of variety. As far back as the 1960s he had mentioned this concept, and it finally came to fruition in 1975 in support of the Desire album. It was when watching the Rolling Stones at Madison Square Garden in 72 that Bob found his passion for live performance reignited. He wanted to join the party again. So while Tour 74 had been emotionally draining for him, Rolling Thunder Revue was the total opposite. Many a character came on board, some briefly, others for the whole tour; Rob Stoner, Scarlet Rivera, Mick Ronson, Joan Baez, Joni Mitchell, Roger McGuinn, Ramblin' Jack Elliot, Larry Ratso Sloman... the list goes on. No wonder the tour inspired the Renaldo and Clara movie, for Dylan, in effect, had the best cast imaginable already assembled together.

This, for me, is the great golden period of Bob Dylan's career - the mid seventies. I love the muted, crusty early seventies for all their oddness and quirks, but this was truly a special age. In his mid thirties, Dylan had cut two classic albums - Desire and the earlier Blood on the Tracks - and instigated one of the finest tours in the history of rock. With white face paint, theatrical hat, waist coat and manic mannerisms, Dylan came to life before the crowds who were in awe of his new burst of creative energy. This was a different man from the calm, stiff crooner at the Isle of Wight. Here before them was a barking circus ring leader, ghostly faced, arms everywhere, conducting his band of merry men like a demented mad hatter.

Larry "Ratso" Sloman, who wrote the fantastic book about going on tour with Bob, shared his thoughts with me about the shows. "What's vivid is the music. Amazing performances night after night from everyone, especially Bob. Like he said at the end of my book, 'Ratso, did I ever let you down onstage?" Answer was a resounding NO! I found him tremendously easy to engage with. You can read my book and see that he was loose, funny, caring and above all else, a great artist. You don't need a Nobel Prize to know which way the wind was always blowing. For a guy that's impossible to capture, I think I did a commendable job (in the book, On the Road with Bob Dylan). It's a real honest slice of time."

For all the joys of watching the baffling, overlong, but admittedly brilliant Renaldo and Clara, anyone who says the live footage is not the film's highlight is not much of a Dylan fan. He is magnetic in the concert segments, and no matter how watchable everyone else is around him (the wild haired Scarlet for example), Bob is always the one the eyes fix on to. He is on fire, literally the greatest rock and roll performer of all time in this one year of touring. Where did this energy come from? Was this a character he adopted for the film and this particular live jaunt? Was this a forced persona he fancied exploring for a short time? Or was it unconscious? Did it just happen? I suppose we will never know, but we have the evidence to show us how special this time was. The evidence may be hard to come by - at least the video footage - but it's there if you want it.

There are, of course, audio documents of this tour too, both official and in bootleg form. Hard Rain, recorded and released in 76, is an album that captures the excitement of the Rolling Thunder vibe and set list. Recorded for a TV special in Colorado, the band are blistering

throughout. The musicians are balls of energy and Dylan himself has never sounded more excited, wound up and captivating. You hang on his every word here, as the band play on beneath his enraged poetry. Scarlet Rivera's violin screeches and howls, the rhythm section is as tight as can be, but the real star is master of ceremonies, Bob Dylan.

The opening bombast of Maggie's Farm clears the way for the full on onslaught this record is, with a thrilling version of Stuck Inside of Mobile with the Memphis Blues Again. There's also a vicious take on Idiot Wind that's better than the album version, a barking mad Dylan backed up by a band firing on all cylinders. Recorded at Hughes Stadium in Colorado, it was also filmed for television and the resulting visual document is as exciting as the compelling sound recording. This era was also captured brilliantly on the Bootleg Series Vol. 5, the Rolling Thunder Revue instalment, but Hard Rain is extraordinary. The 2002 release of the Bootleg Series features some truly startling performances captured from the amazing Rolling Thunder Revue era. There is real magic on the solo Dylan acoustic performances, the likes of Tangled Up In Blue and Love Minus Zero/No Limit especially, but when backed by the whole band on the Desire material, Dylan simply explodes with life. Listen to his voice on Hurricane - we all know the man felt passionately about Rubin's wrongful imprisonment, but anyone who says Dylan cannot sing in the traditional sense, whatever that means, should really check this out. There is real passion and energy to this rendition, with the whole band skating effortlessly through the epic track behind him. Scarlet Rivera's electric violin howls throughout and Dylan spits out the lyrics with equal amounts of conviction and venom for the wrong doers. It's easily one of Dylan's finest live moments captured on a

recording that I have ever heard. The recording of the Rolling Thunder gig at Plymouth in October 75 is also indispensable stuff for the Rolling Thunder fan, but the sound quality on this one takes the prize as best Rolling Thunder recording.

Rather unexpectedly, Dylan only waited two more years to go out on the road for yet another tour. Asked why he chose to venture out again by Rolling Stone in 1978, he replied, "Well, why did I do the last one? I'm doing this one for the same reason I did the last one. It was for the same reason that I did the one before that. I'm doing this tour for one reason or another, but I can't remember what the reason is anymore. There are more important things in the world than money. It means that to the people who write these articles, the most important thing in the world is money. They could be saying I'm doing the tour to meet girls or to see the world. Actually, it's all I know how to do. Ask Muhammad Ali why he fights one more fight. Go ask Marlon Brando why he makes one more movie. Ask Mick Jagger why he goes on the road. See what kind of answers you come up with. Is it so surprising I'm on the road? What else would I be doing in this life – meditating on the mountain? Whatever someone finds fulfilling, whatever his or her purpose is – that's all it is."

We find that whatever Dylan says is taken more seriously than it is intended. He gives straight answers but the press and admirers seem to want to pull more out of him. It's a weight that comes with all celebrities in their many forms, but it seems worse with Bob, probably due to the oracle prophet persona he unwittingly garnered in the 1960s. If Bob tells an interviewer he's touring because it's his job and it's all he knows how to do, they assume there just has to be a hidden message in there. They say he was broke and needed the

money, which is impossible when you consider his advances from Columbia and his sizeable royalties, not to mention money gained from past concert appearances. Everything Bob does is dissected and pondered over, the same way folk are trying to unravel the apparent mysteries of his modern day Never Ending Tour. It's a term Bob himself balks at, and you can see why. People are so keen to put artists in boxes, to neatly define what they do and why they do it.. As Bob said in a 2015 interview, "I'm just a musician." It really is, I truly believe, as simple as that. He's a touring musician who happens to stop now and then to make an album. If anything, Dylan's 78 tour is but a precursor to his current live activities; a constant stream of concerts taking in all the countries that will have him as a guest.

Thankfully, we have the Budokan live LP, which represents Dylan's massive world tour of 78. Although the radically altered versions of familiar hits on this record seemed to rub critics and some fans up the wrong way, Bob Dylan at Budokan for me is a brilliant live album. The 1978 tour had Dylan backed up by an arguably oversized but solid band. As heard on this album though, the songs often sound cluttered. Still, there are some great renditions here. The Japanese flavour of Maggie's Farm for instance is one of the finest versions of the song, which often sounds tired on the various live albums it's played to death on. Mr Tambourine Man sounds good too with its odd Jethro Tullish flute lines. There are great takes on the likes of All Along the Watchtower and One More Cup of Coffee, albeit in a more rocked up form. In all I think it's a really enjoyable album; crowd pleasing yes, and although it has a slight Neil Diamond showbiz feel to it, it's still a well played and often thrilling set. After

all, Bob has never stuck to one style and even though this gets its fair share of criticism, it's an interesting addition to his live catalogue.

It was during the World Tour that something clicked in Dylan, when his whole outlook and world was to be altered completely. "Towards the end of the show someone out in the crowd," Dylan recalled in 1979, "knew I wasn't feeling too well. I think they could see that. And they threw a silver cross on the stage. Now usually I don't pick things up in front of the stage ... But I looked down at that cross. I said, 'I gotta pick that up.' So I picked up the cross and I put it in my pocket... And I brought it backstage and I brought it with me to the next town, which was out in Arizona... I was feeling even worse than I'd felt when I was in San Diego. I said, 'Well, I need something tonight.' I didn't know what it was. I was used to all kinds of things. I said, 'I need something tonight that I didn't have before.' And I looked in my pocket and I had this cross."

It was seemingly as simple as that. His girlfriend at the time, Mary Artres, was a born again Christian, and in her presence he claimed to get a personal visit from Jesus himself. Though it sounds dramatic and is maybe not so literal, Dylan felt the hand of Christ upon him. He was officially ministered and took to faith as intensely as he once had to marriage and family life. He claims he often overlooked beauty created by God, and focused too much on man-made beauty, This was all about to change. It was the start of a new chapter, but also the end of a golden age.

Bob had started to introduced the religious material at the end of 78, and found himself surrounded by born again Christians and people interested in the faith, like T Bone Burnett, Steven Soles and David Mansfield. Dylan was clearly searching for something, as he

indeed had been doing for the whole of the 1970s, flitting from one thing to another, whether it be a tour, a home, a movie, or a state of mind. He was aimless, lost at sea, and the cross presented him with a haven, some change, a reason and a purpose.

Late in 1979, Dylan and his band played three new songs on Saturday Night Live, all religiously themed, and then went out on a mini tour that saw him to early December. It was to be picked up again in early 1980, a new decade and a totally new story all together. The classics were out of the set list, nowhere to be seen in the vast array of new songs, all born again Christian themed. Dylan rightly argued that anyone who wanted to hear the anthems and the oldies could have done so the previous year, on his mammoth 78 tour. This however was a new show, a new idea, presenting brand new tracks to his audience, and ignoring the back catalogue. It was a brave move and the crowds were not happy. But Dylan was persistent. This was his new direction, *his* choice, and he was fired up by it, charged by the will of the Lord.

On all the seventies tours, Dylan was a passionate performer, even if he didn't often feel like one. The 74 and 78 tours had been a compromise, for money or obligation, while the Rolling Thunder was an exciting idea that came to life unexpectedly and organically night after night. The Gospel tour, its first leg finishing off the 1970s, was something much deeper, more personal and intense. The shows were an extension of Dylan as a man, in his beliefs and vision. You either accepted that or not. The loyalist ones stayed along for the ride, although even they would almost run out of patience.

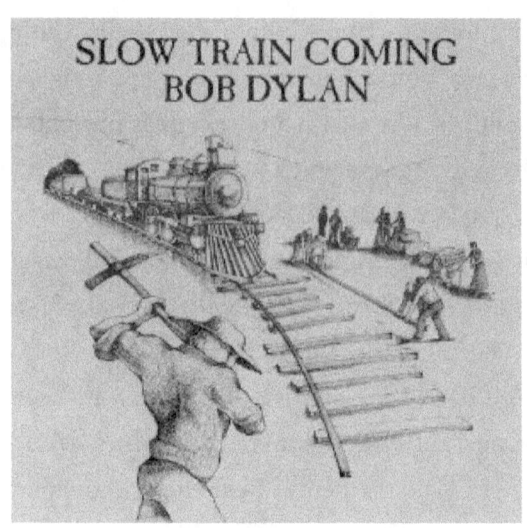

SLOW TRAIN COMING

And the Dawn of Christianity

And here he is, on record; it's official - Bob Dylan in all his born again glory. While nowhere near the powerful transcendence of Blood on the Tracks, or the colourful, peacock strut of Desire, Slow Train Coming is clearly a personal, impassioned and meaningful statement from one of the greatest artists of all time, and for this reason alone it needs to be valued and closely inspected, rather than written off as a kooky example of his great erratic stubbornness. Whether the clean production, weighty subject matter or general sound is up your street or not, this is a strong album that cannot be ignored or overlooked. It's very important in Dylan's development and essential listening for anyone interested in his ever changing style.

The sound is completely different to the last album, being much sharper and more produced. The drums are clean, almost robotically

clear, and Dylan's voice is crisp and precise, more precise than ever before in fact. Opening track, the preaching Gotta Serve Somebody, illustrates this fact. Dylan is still Dylan, that trademark voice still evident, yet he sounds more sure than he has for years. Whoever you are, Bob insists, we all have to serve someone. There is someone to answer to, but we should only hold ourselves to blame. With a fine band around him - Mark Knopfler on guitar, the three backing vocalists once again, and Tim Drummond to name a few - Bob sounds confident and believes what he says. For the first time in a while, he doesn't appear to be hiding behind voices, characters or nuances. He's singing something he believes in, with much emphasis on the fact that it may just be the Lord himself whom you're serving. Though John Lennon dissed the track (writing Serve Yourself in response to it), it's a brilliant song, catchy as hell (blasphemous, I know) and played with neatness. Neatness, now there's a word you wouldn't have used for many a Bob Dylan record before this.

Songs like Precious Angel may bring to mind earlier Dylan chord sequences, but they are laced with flashy Knopfler guitar parts (Cinton Heylin's favourite guitarist!) and the tidiest production you've ever heard on a Dylan LP. While very Dire Straits in parts, the album shines on the likes of I Believe In You and Gonna Change My Way of Thinking, due to Dylan's fondness for the songs and the messages behind them. Do Right to Me Baby (Do Unto Others), with its funk and groove, is possibly the finest cut here, with Dylan sounding comfortable and vital.

William Stetz is an artist and photographer who put together the striking cover for Slow Train Coming, among the most arresting

facets of the finished product, for want of a better word. I asked him how he got involved in the album sleeve design.

"I was drawn into a design project for Bob Dylan through Jude Elliott, the girlfriend of my friend David Stafford," William told me. "Jude was working as an assistant to Bob Dylan who had opened a studio in Santa Monica - Venice, CA on Main Street south of the corner of Pico Blvd. This was a warehouse looking building where Jude worked and Bob used as a base/studio. Jude knew I was a designer and photographer (I had been working for a motion picture title designer up to that time) and asked if I would be interested to pitch an idea to Bob for his new album, his first Christian-themed album. CBS was the publisher for Dylan at the time and although I went through the company later on, Dylan garnered all the creative that he wanted up to the production phase of the work. I met Jude upon finding the Main Street space and we went upstairs. It was mid-morning a couple of blocks from the beach. She led me to the second floor of the loft, a large room that took up a lot of the second floor, and then to a smaller room that faced the street. My first meeting with Dylan was in that room of the warehouse. Bob entered the room and was more slight than I imagined. I was 5'11" and he was shorter and slim. Jude introduced us and then left. In business-like manner I extended my hand to shake his and immediately realized that he wasn't used to shaking hands with people, but took my hand and we exchanged a timid grasp.

"Dylan stood with his back to the warehouse window in the bare room, so he was somewhat in silhouette to me or side lighted as he turned profile to the window. He was soft spoken and didn't say too much, but he wanted me to get a flavour of the music to work with so

he produced a cassette tape (which he wouldn't allow me to take) of some of the music on his album. I remember him using a small portable cassette player to play Gotta Serve Somebody and we stood quietly while the music played and then he left the room while I listened to more of the music. Dylan never expressed or described any visuals to me. It was all about the music. He gave me full reign to come up with something in the way of art and I never felt that I was in competition with the record company or another artist that might be coming in the door. I felt some pressure about coming up with a design that would be appropriate to a musical artist that I respected and admired for so many years while at the same time Dylan's so completely unpretentious demeanour let me concentrate on my ideas all to myself. I left that meeting that day and began my process.

"Usually, as is the case, my first ideas come on the strongest and working from an original first thought often takes precedence to working and re-working an idea," Stetz continues. "Slow Train Coming. It presents the obvious of the train, a progression of forward movement, ideas, people, forces. A train is a train — and all that other stuff, too. But this train, is a movement of spirit, conviction and forces of man and god. This was Dylan's vision of religion, Christianity and so building upon that idea I introduced the cross through the axe and made this "slow train," the movement of mankind down a track that was being laid all honed by the cross-wielding worker that would pound the spike.

"I contracted an illustrator, Catherine Kanner, to do the drawing which became a composite of pieces of drawings that were patched together to make the final work. I met Catherine Kanner through

another work position that I had. I still own the original pieces of that work. From the composite, I had a film positive made of the line drawing and sandwiched it over brown construction paper in the size of the album cover for presentation. This gave it the old printing effect of having been produced on paper which had discoloured or was of less than high quality paper stock. And, it looked like an album. I never heard directly from Dylan what he thought of the work, but it must have made an impression as I did hear from the CBS art director for contractual arrangements to purchase the work. Jude, seemed to think that Dylan liked the work a lot, so I was pleased with that. I am happy that the artwork was produced and am very proud that the idea took flight. I maintain Bob Dylan as one of the greatest artists of our time and having played some role in his work makes me very happy. I only wish I had the opportunity to do his photographic portrait. That's for another time..."

Though the album sold well, and went Top 5 in the US and the UK, some of the critics tore it to shreds. The hammering was up there with Self Portrait. Again, they pondered, what the hell had happened to their shaman? However, there were just as many people who accepted Dylan's new phase as there were who hated it.

"It takes only one listening to realize that Slow Train Coming is the best album Bob Dylan has made since The Basement Tapes," Rolling Stone raved, referring of course to the 1975 release of the sessions recorded in 1967. "The more I hear the new album — at least fifty times since early July — the more I feel that it's one of the finest records Dylan has ever made. In time, it is possible that it might even be considered his greatest. This claim will not go down easily, especially with all the "born again" clamour. So much emotion has

become invested in Dylan's public image that the greater numbers of his critics and devotees torture themselves before they will put aside their previous definitions of him. In fairness, his followers have seen his work steadily weaken for almost a decade and have legitimate reasons to be extremely rigid. Bob Dylan once again has something urgent to sing. He's back in the land of opportunity, fate and inexplicable twists. Slow Train Coming, built on an accumulation of reluctant and arduous changes, is the record that's been a long time coming, with an awesome, sudden stroke of transcendent and cohesive vision. This is what makes it so overwhelming. Bob Dylan is the greatest singer of our times. No one is better. No one, in objective fact, is even very close. His versatility and vocal skills are unmatched. His resonance and feeling are beyond those of any of his contemporaries. More than his ability with words, and more than his insight, his voice is God's greatest gift to him."

Wenner of Rolling Stone had good reason to praise the record. After all, Dylan had crooned in an arguably nonchalant manner on Nashville Skyline and Self Portrait, while many believe he was sleepwalking through the latter. He was back but reserved on New Morning, and it proved to be a brief resurgence. The 73 outtake album Dylan was considered a joke, with ramshackle production and what many saw as careless vocals from him. Planet Waves and Blood on the Tracks were classics, the latter particularly so, but Dylan sounded sad, lost and hurt in himself. He was not a happy man in 1974-5, and expressed his distaste for the listeners who seemed to delight in his personal torment (though he also bafflingly claimed the LP was not autobiographical at all). Desire and the Rolling Thunder also reflected a restless spirit, a travelling man with no

answers who, rather ironically, was still held up as the man with the answers for us all. By 1979 and Slow Train Coming, one thing is for sure, and that is that Dylan sounds content to a certain degree, and seems to know where he is heading. He's a man with a purpose, a strong sense of self and his faith. This shines through on the record

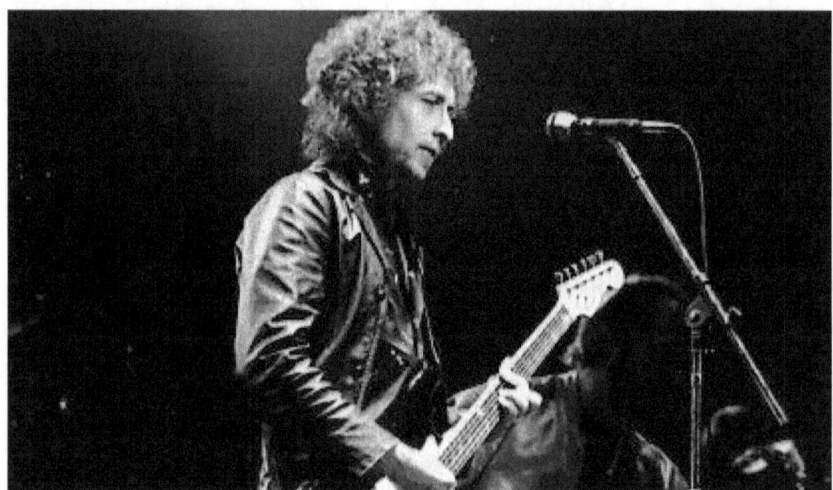

which is still to this day his most uplifting and positive album. He marries great lyrics with fine musicianship, enjoyable hooks and a deeper meaning that elevates the record from a standard set of songs. These are Dylan's beliefs in 1979, a time capsule of a man getting in touch with the truth and his inner self. If he ever had a message, it was then. Unfortunately, no one was willing to listen. After waiting with bated breath for *anything* from their hero, it's ironic that when he finally surfaced with something of substance that he believed in passionately, all they could do was cry out for Lay Lady Lay.

"I guess He's always been calling me", Dylan said in 1980. "Of course, how would I have ever known that? That it was Jesus calling me. I always thought it was some voice that would be more

identifiable. But Christ is calling everybody; we just turn him off. We just don't want to hear. We think he's gonna make our lives miserable, you know what I mean. We think he's gonna make us do things we don't want to do. Or keep us from doing things we want to do". "But God's got his own purpose and time for everything. He knew when I would respond to His call."

Bob Dylan had found the goal, the reason to keep going. But his fans wanted more Blood on the Tracks venom, more heartbreak, more turmoil, more Van Gogh torment being poured out on to tape, not righteous preaching. So begins one of Bob's great misunderstood, and also most interesting periods. Bob Dylan as born again Christian who refuses to play the old hits. Shock, horror!

Bob, however, did understand his fans' brash rebelliousness - the booing, the catcalling - and their dissatisfaction in his refusal to play the older tracks. "I can understand why they feel rebellious about it because up until the time the Lord came into my life, I knew nothing about religion," Bob told Pat Crosby at the start of the next decade. "I was just rebellious and didn't think much about it either way. I never did care much for preachers who just ask for donations all the time and talk about the world to come. I was always growing up with "it's right here and now" and until Jesus became real to me that way, I couldn't understand it. They (the fans) want the old stuff. But the old stuff's not going to save them and I'm not going to save them. Neither is anybody else they follow. They can boogie all night, but it's not gonna work." He also added, somewhat reassuringly, "Oh I love that stuff," in reference to his old material. "I look at it now and it amazes me that it was me who even wrote it."

For now though, "that stuff" was behind him.

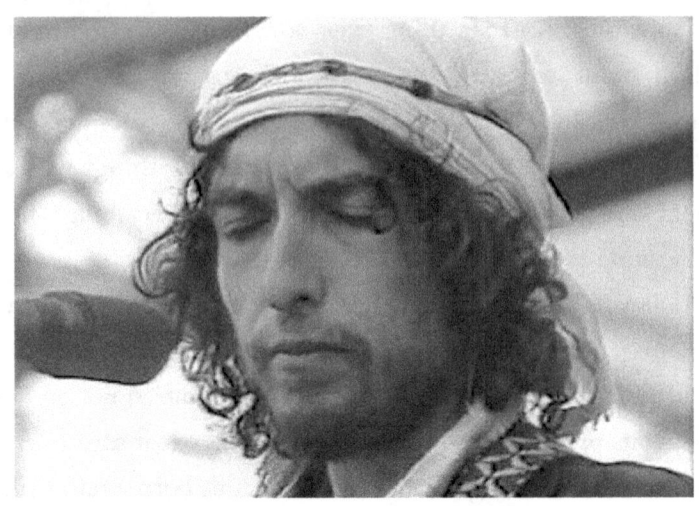

POSTSCRIPT

For all the talk of Bob Dylan being the guide, voice and leader of a generation or two, the 1970s paint the portrait of him as a drifter, for the most part just as lost as your average Joe. After all, lest we forget, he had begun the decade as a content family man releasing easy listening LPs that riled up the critics. After, he'd got the itch for the road once again and toured the globe, leaving his family at home. Then he did it again with a band of assorted misfits, before splitting from his wife, Sara, who he had been content with for a decade or so. He saw the decade out as a born again Christian, performing intimate concerts of all new religious material, only playing the songs the Lord gave him. It had been a wild ten years, that's for sure, but then again, the ten years to follow were just as unsteady and unpredictable. Dylan would ease down his religious material and become more accessible in concert. However, the quality of live

performance and his recorded work would suffer as the years went on. He toured with The Grateful Dead and Tom Petty to lift him from his creative dip, and recorded with his all star chums for the Traveling Wilburys project. The 1970s had been varied and colourful, but the 1980s were rocky and slightly grim. Still, Dylan would rise from the ashes again.

A look back at the 1970s reminds me that Bob had what was possibly his most fascinating decade as a performing and recording artist. He was an icon, both clinging on to and running away from his past; at one point retreating, then taking back to the world stage to remind them he still existed, and was still the best of all the great song writers. He had Number One albums, the biggest tours the world had ever seen, a series of dips and peaks that an artist usually fails to pack into a full career, never mind just ten years. While all the material in the 1970s may not be as instantly iconic as his 60s anthems and classics, it makes for a more mixed, flawed and appealing jumble of misfires, jackpots and triumphs. He had regained his status as rock's great poet, its leading light, only to lose it again at the end. How conscious or unconscious all this was (I'm going with the latter), it inevitably goes in line with the world's view of Bob Dylan as the great enigma, the journeyman, the master of illusion, the travelling troubadour who has lived the lives of a hundred men. Close to 40 years since the end of 1970s, Dylan is still out there, alive and well as fellow heroes drop. He's painting, recording and touring. He walks amongst us still, this mythological figure who lives like a true poet; the outsider who wins the prizes but refuses to collect them. There have been many new mornings for Bob Dylan, and hopefully there will be many more to follow.

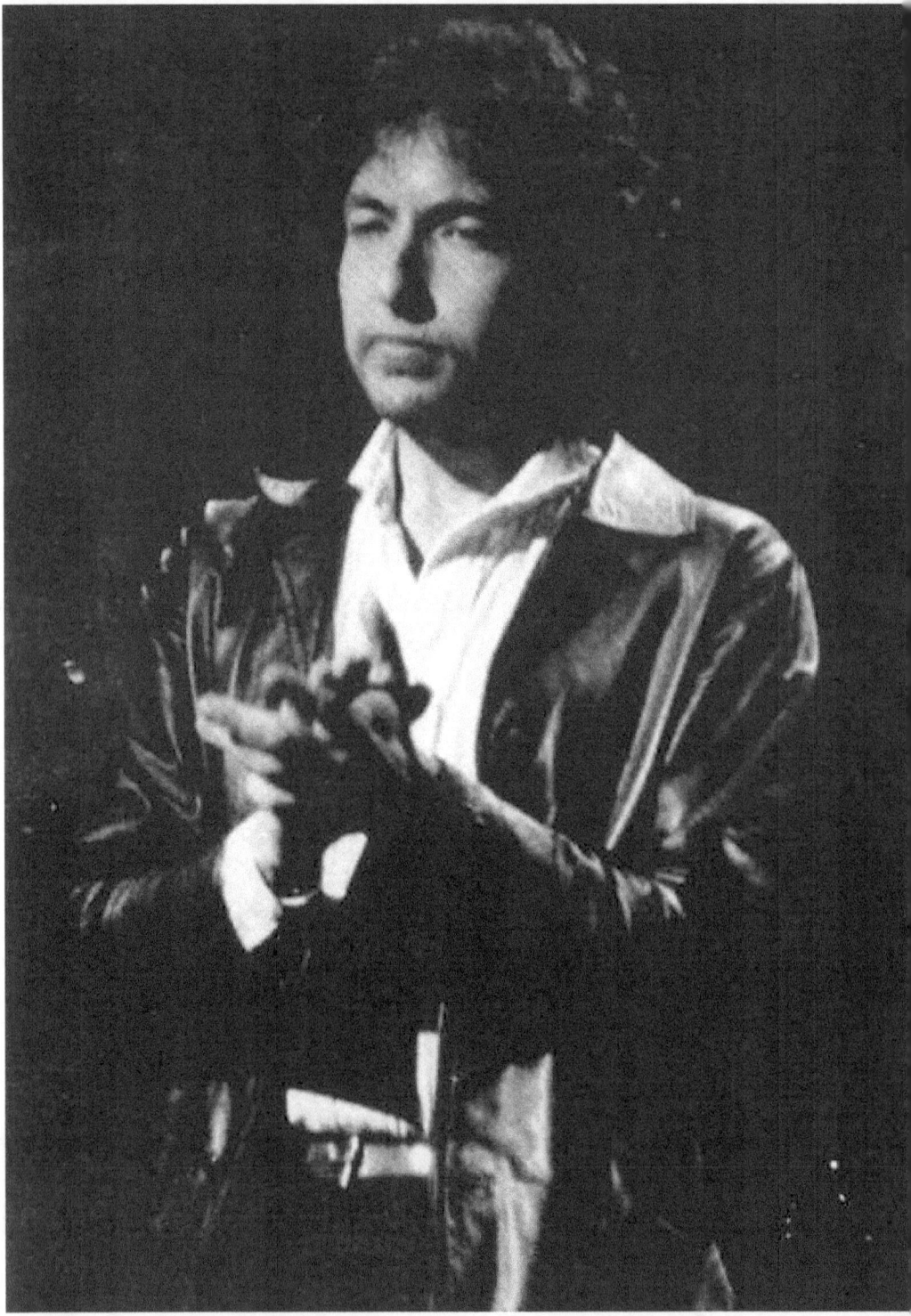

BOB DYLAN
1970s Discography

Albums

Self Portrait (1970)

New Morning (1970)

Pat Garrett and Billy the Kid (1973)

Dylan (1973)

Planet Waves (1974)

Before the Flood (1974)

Blood on the Tracks (1975)

The Basement Tapes (1975)

Desire (1976)

Hard Rain (1976)

Street Legal (1978)

Bob Dylan at Budokan (1979)

Slow Train Coming (1979)

Other notable albums with 70s material:

Bob Dylan's Greatest Hits Vol. II (1971)

Masterpieces (1978)

Bootleg Series Volumes 1 - 3: 1961 - 1991 (1991)

Bootleg Series Vol. 5: Rolling Thunder Revue (2002)

Bootleg Series Vol. 10: Another Self Portrait (2013)

Singles

Wigwam (1970)

If Not For You (1971)

Watching the River Flow (1971)

George Jackson (1971)

Knockin' On Heaven's Door (1973)

A Fool Such As I (1973)

On A Night Like This (1974)

Something There Is About You (1974)

Most Likely Go Your Way - Live (1974)

All Along the Watchtower - Live (1974)

Tangled Up in Blue (1975)

Hurricane (1975)

Mozambique (1976)

Rita May (1977)

Is Your Love In Vain? (1978)

Baby Stop Crying (1978)

Changing of the Guards (1978)

Love Minus Zero - Live (1979)

Gotta Serve Somebody (1979)

Precious Angel (1979)

References and Acknowledgements

The material in this book was enhanced by interviews and exchanges, both new and old, with the following people; William Stetz (website: wmstetz.com), Larry "Ratso" Sloman, Arlen Roth, Happy Traum, Charlie McCoy, Scarlet Rivera, Rob Stoner, Greg Inhofer, Kevin Odegard, Billy Peterson, Buddy Cage, and Don Meehan.

The following books were helpful;
Bob Dylan Performing Artist 1974 - 1986, Paul Williams
Behind the Shades, Clinton Heylin
Revolution in the Air, Clinton Heylin
Shelter from the Storm, Sid Griffin
The Music of Bob Dylan, Chris Wade (shameless I know)
Down the Highway, Howard Sounes
No Direction Home, Robert Shelton
Dylan on Dylan
Chronicles, Bob Dylan
Oh No! Not Another Bob Dylan Book
Rolling Thunder Log Book, Sam Shepard
Dylan by Mojo
Song and Dance Man, Michael Grey

ABOUT CHRIS WADE

Chris Wade is a UK based writer and musician. As well as running the acclaimed music project Dodson and Fogg, he has written books on The Kinks, Madonna, Frank Zappa, The Incredible String Band and many more. He has also released audiobooks of his comedic fiction, narrated by such actors as Rik Mayall, and edits the ongoing free publication Hound Dawg Magazine.

More info at his website: wisdomtwinsbooks.weebly.com

www.ingramcontent.com/pod-product-compliance
Lightning Source LLC
Chambersburg PA
CBHW060854170526
45158CB00001B/354